Tynnwyd yn ôl

URBAN BOTANICS

AN INDOOR PLANT GUIDE
FOR MODERN GARDENERS

MAAIKE KOSTER
and
EMMA SIBLEY

WHITE LION
PUBLISHING

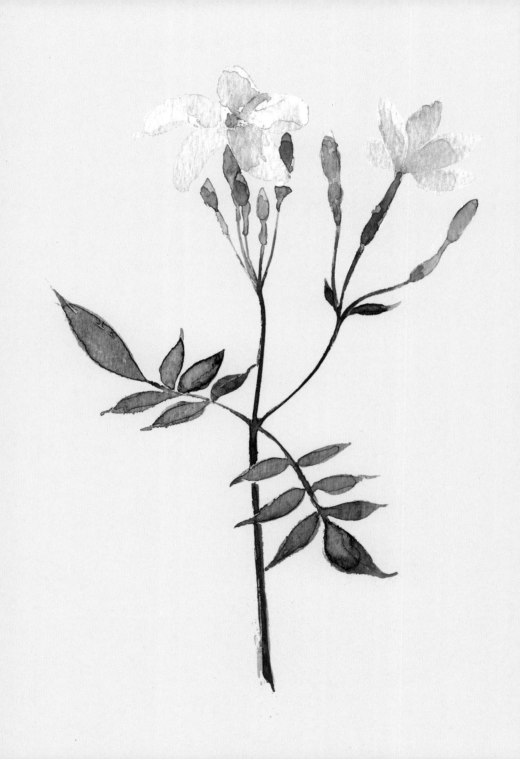

CONTENTS

INTRODUCTION

Growing plants in an urban environment can be the ideal way to make a small space feel open and alive, and with a surge in the popularity and availability of house plants it is increasingly easy for us to adorn our homes with them. In recent years we have seen a growing trend for house plants as more and more people appreciate the benefits of being surrounded by greenery in the home. All around us we can see a multitude of fashion and lifestyle campaigns styled using tropical palms, ferns and foliage, and there is also an increased abundance of places selling plants for the modern gardener.

In the past few years there have been some real changes in attitudes towards house plants. Instead of giving a bouquet of flowers, people now exchange living plants – perhaps an arrangements of succulents in small pots, or a plant they have propagated themselves, such as the easily-grown spider plant. Once usually seen limp in the corner of a tired office or apartment, today spider plants seem to be taking centre stage along with the likes of palms and rubber plants, all of them bringing the outdoors into a modern home.

Green foliage plants are certainly growing in popularity – the painterly leaves of calathea, a towering rubber plant or delicate maidenhair fern – but perhaps leading them all are cacti and succulents. This could be down to the notable low maintenance of this group of plants, or to the sheer variety and unusual-looking selection that has become available. The small size of many of them also makes them useful in a restricted space, allowing them to be arranged neatly and popped on a window ledge, for example.

In a time where living within an urban environment rarely involves having access to a lush garden, buying house plants can be the perfect solution. People are realising that you don't have to have a full garden to show off your green fingers. Our enthusiasm for filling our apartments and studios with potted plants has proven the urban gardener can have as much success as someone with a bountiful outdoor space, and there's the added bonus that you can take your plants with you if you move.

Don't believe in the myths of 'green fingers' or 'black thumbs'; everyone can grow house plants! We hope you can be inspired by the variety of house plants there are to choose from, as this book guides you through succulents, cacti, flowering and foliage plants and towards being the truly successful modern gardener.

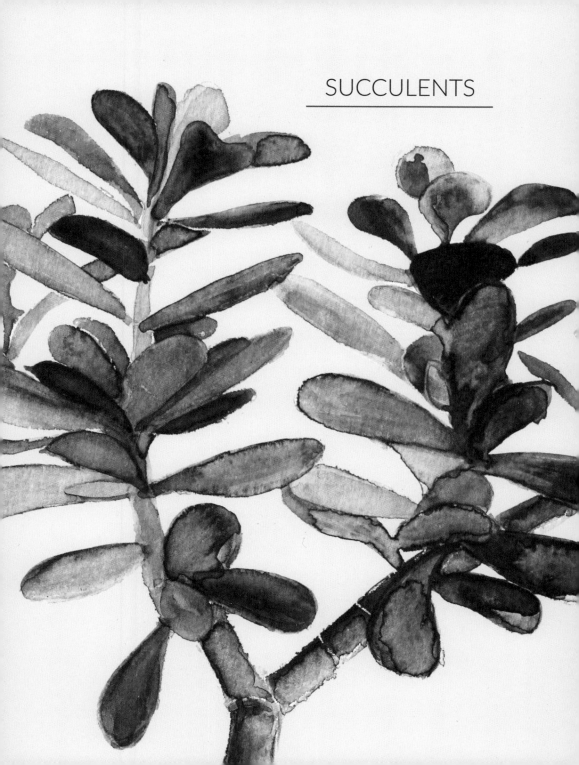

Adenium obesum
Desert Rose
Africa and Arabia

An evergreen succulent shrub that enjoys winter warmth, the desert rose thrives in a conservatory or on a draught-free windowsill. The plant forms a bulbous, swollen base from which bare, woody stem protrude, with clusters of green, leathery leaves at the top.

Ample sunlight and warmth throughout the year are the perfect conditions for the desert rose, encouraging the production of flowers during the summer months. When it comes to watering, make sure that you water regularly from spring to autumn but during the winter resting period keep almost dry, only watering once every few weeks.

The beauty of these plants is when they flower. The tubular, singular flowers, in bright pinks and reds, form a vibrant contrast to the bright green leaves.

DESERT ROSE
ADENIUM OBESUM

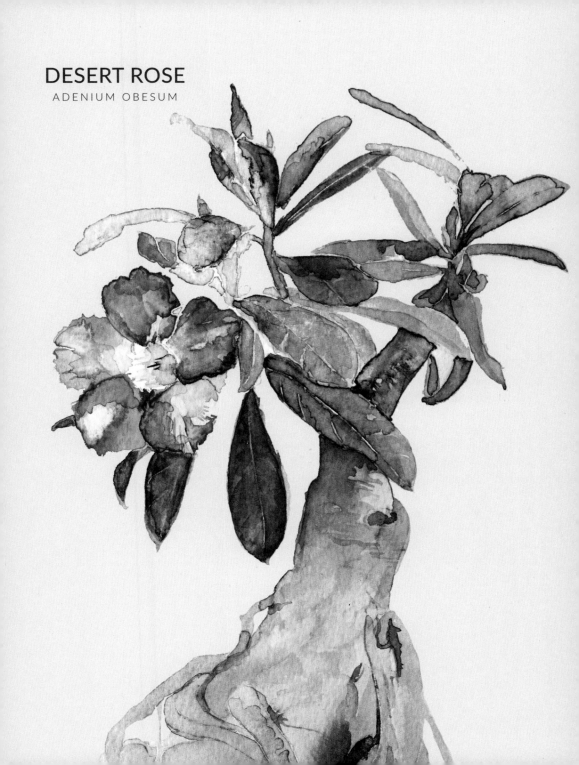

Aeonium 'Sunburst'
Copper Pinwheel
Canary Islands

This branching succulent grows to form large variegated rosettes of green and yellow leaves on the ends of woody stalks that can sometimes reach 50 cm/20 in high. The edges of the leaves will sometimes show a pink hue; this will increase with exposure to sunlight and also when the plant is exposed to extremely cold conditions.

The copper pinwheel requires full sun to light shade. Be careful when placing plants in direct sunshine, however, as this can damage and brown the leaves; you may also see them start to curl up to prevent excessive water loss.

Most aeoniums are dormant in the summer months and during this time may not require any water except if the leaves seem to start to shrivel, in which case water sparingly. During the growing period of winter to spring they will thrive in a moist, shady spot. Water once a week but allow the compost to completely dry out between waterings as aeoniums are quite prone to root rot.

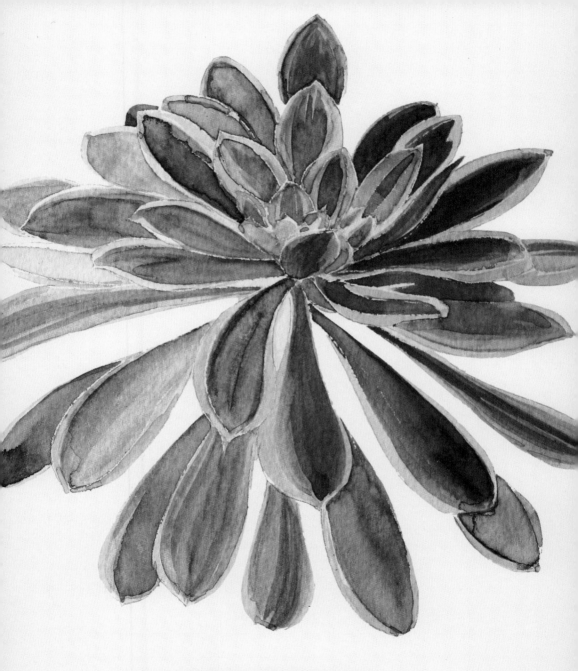

COPPER PINWHEEL
AEONIUM 'SUNBURST'

Aeonium Volkerii
Tree Houseleek
Canary Islands

This houseleek forms a compact branching plant with light green, fleshy leaves that have distinctive, bright red margins. The leaves form fleshy rosettes of four to five layers.

Unlike most succulent plants, *A. volkerii* does not enjoy the dry desert conditions that you would expect, favouring more shady and moist conditions. During the summer months if the atmosphere is too hot and dry you may notice the leaves shrivelling, an indication that the plant is need of water. Although preferring a lightly shaded spot, some exposure to sunlight will enhance the colour of the plant, increasing the red tones on the edges of the leaves.

During the winter months this aeonium should only be watered when the soil has completely dried out. Never allow the plant to stand in water at any time of year, as it is very prone to root rot.

Repot every two years in the growing season, which is late winter or early springtime.

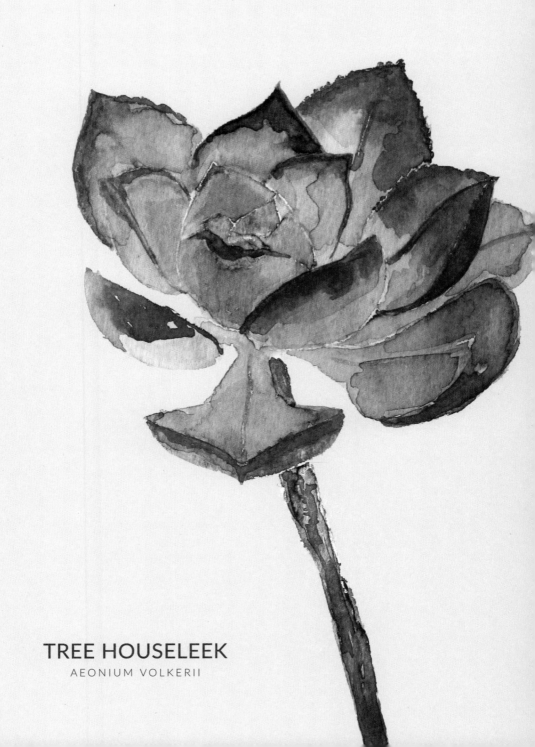

TREE HOUSELEEK

AEONIUM VOLKERII

Agave americana
Century Plant
South America

There are over 300 species of agave, the most popular being A. *americana* or century plant – so-called because of the false belief that it will flower only once a century. Agaves have rosettes of elongated, blue-green, often toothed leaves which are notoriously strong.

These desert plants favour an abundance of strong sunlight. During the summer months water with warm water and do not allow the compost to dry out; however, during the winter, water very rarely as the plant goes into hibernation mode then.

As it is a very slow growing plant you can keep your agave inside for many years, but you may want to move it outside in summer when the spines on the leaves start to get too large, as they can become quite unruly.

Agaves are difficult to grow from seed and will rarely flower indoors, but they are very easy to propagate from offsets. They produce many of these, which root whilst still attached to the parent. These can then be pulled off and potted up separately, giving you many agaves from your initial plant.

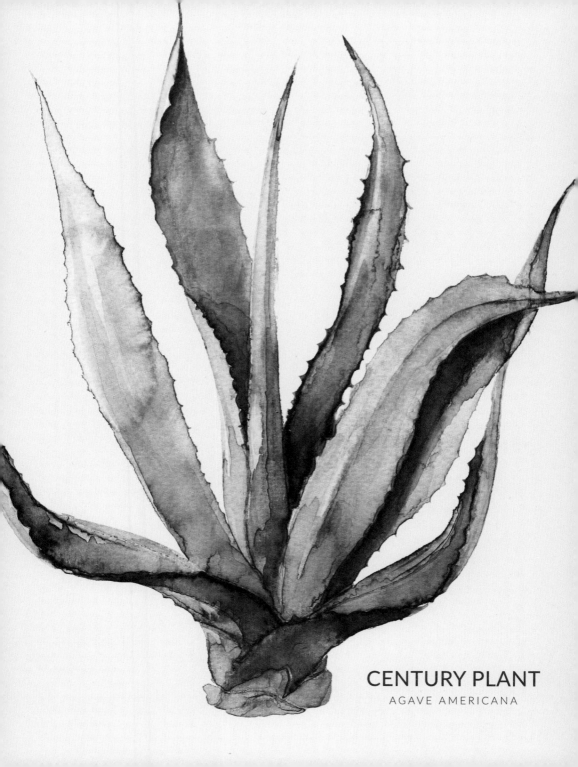

CENTURY PLANT

AGAVE AMERICANA

Agave parryi
Cream Spike
Arizona

With remarkably tough grey green rosettes, it is easy to recognize this agave from its distinguishing pointed tip that appears much darker than the rest of the leaf.

Surviving easily in most conditions, agave does prefer a hot, dry environment; keep in a pot of gritty soil on a window ledge where it will experience long periods of sunshine. In the height of summer, though, it is advisable to allow the plant a period of afternoon shade.

Moderate watering is needed during the summer months but make sure that the soil is free draining so that the roots do not sit in a damp pot. Allow the compost to completely dry out before watering again. In the winter months you may be able to decrease watering to once every few weeks, only watering sufficiently to stop the leaves from shrivelling.

In its native habitat, flowering spikes may be produced on mature plants, but they generally need to be at least 10–15 years old. Creamy yellow blooms shoot out of the rosette from a long arched spine, which can reach heights of up to 6 m/20 ft. The rosette will die back after blooming.

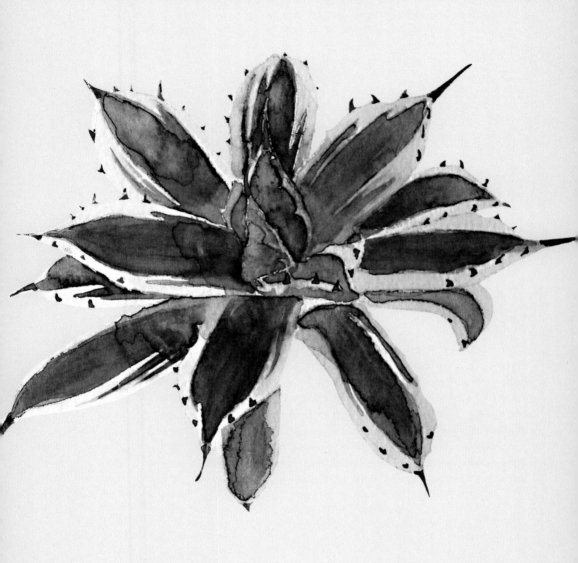

CREAM SPIKE

AGAVE PARRYI

Aloe barberae
Tree Aloe
South Africa

One of the largest aloes, this tree can reach heights of 18 m/ 60 ft in climates similar to its native South Africa, where it makes a great focal point for the garden, especially when adorned with its attractive tubular pink flowers. You are much less likely to be rewarded with flowers in cooler climes, though you may be lucky. The tree aloe will need a lot of room in the home. Use a very large pot with ample drainage. Plants can go outside in a sheltered spot in the summer, but must be kept frost free in the winter months. Propagation of this aloe is relatively straightforward; take cuttings from the stem and allow them to dry over for a few weeks before placing them in soil.

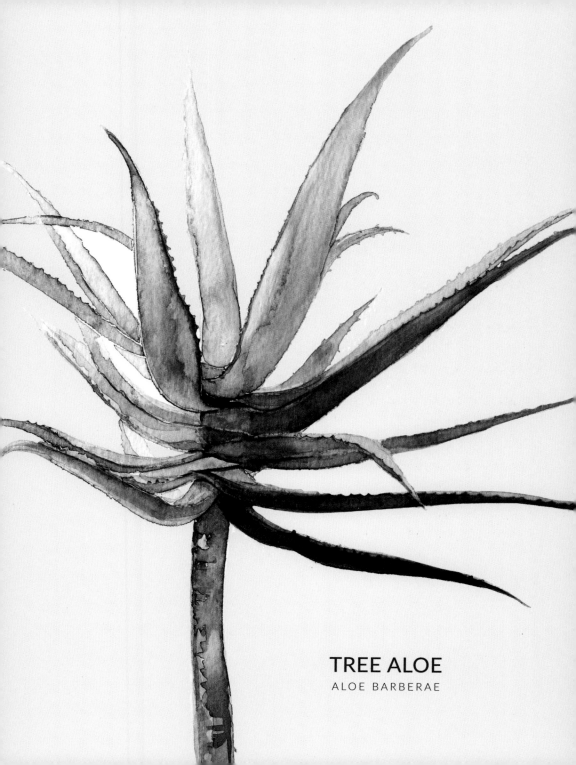

TREE ALOE

ALOE BARBERAE

Anacampseros telephiastrum
Pan American Love Plant 'Sunrise'
South Africa

A low-growing succulent with small pink flowers and long branching stems, *Anacampseros telephiastrum* will do well in a free-draining pot or hanging basket that will allow its stems to hang free. Plants are composed of many rosettes that clump together to form mats. Repotting should be carried out once a year to accommodate the creeping nature of this succulent.

The plant favours a bright filtered light. Don't leave anacampseros in direct sunshine for long periods of time, as this can potentially mark and scald the leaves. It needs low humidity with ample airflow, and frost-free conditions.

Watering should be carried out once a week, with moderate summer watering and infrequent winter watering. Throughout the year you should allow the soil to dry out completely between waterings.

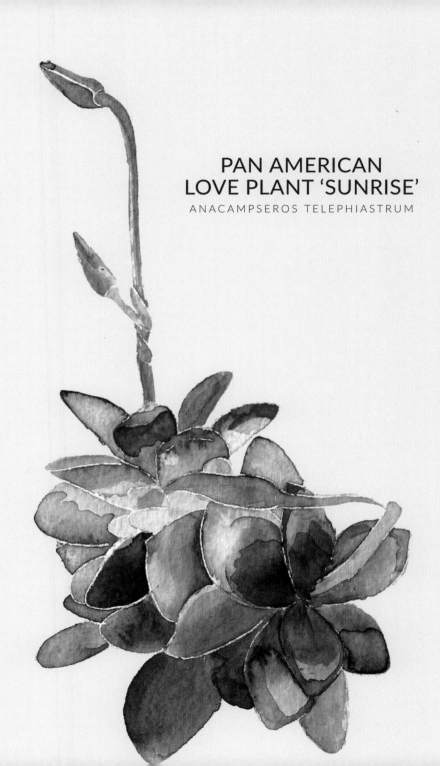

PAN AMERICAN
LOVE PLANT 'SUNRISE'
ANACAMPSEROS TELEPHIASTRUM

Crassula ovata
Jade Plant
South Africa

A very popular and low-maintenance succulent with jade green, oval or teardrop-shaped, fleshy leaves.

During the hot summer months your jade plant will enjoy basking in the heat outside. Place it in a position that receives strong morning sun but then provide a period of afternoon shade for recovery.

Jade plants are very tolerant of neglect, and you will only need to water every two to three weeks. A good way to know it is time to water is if the rubbery leaves start to turn a bit leathery. During the cooler winter months let the plant rest with minimal watering, as cold, damp conditions can be a recipe for root rot.

Starting off as a small shrub, your jade plant will eventually grow into the shape of a tree with a thick, woody trunk. You can use a pair of pruning shears to keep the plant shapely; the shoots that you remove can easily be propagated to form new plants. Lay the cutting on a bed of dry compost until it forms a callus and starts to root, then pot up in a dry compost.

JADE PLANT

CRASSULA OVATA

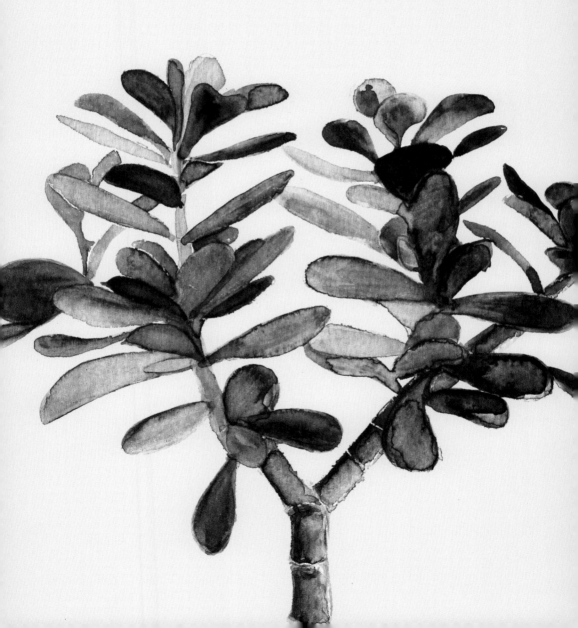

Echeveria derenbergii
Painted Lady
Mexico

An attractive dusky blue-grey colour, painted lady forms pagoda-like rosettes of oval, fleshy leaves. During the summer months the leaves are overlaid with a waxy, pinkish bloom, and the orange-yellow flowers make a bright contrast to the muted palette of leaves.

Watering should be minimal throughout the year as echeveria can store copious amounts in its fleshy leaves. When watering, ensure you don't splash water on the leaves, especially if the plant is placed in a sunny position, as this can cause discoloration and scalding on the flesh. A spell of morning sunshine or late afternoon sunshine, followed by a brief period of shade, will encourage your painted lady to flower, but be careful not to expose the plant to direct midday sun as this can damage the leaves.

This echeveria needs space to grow; if planted too close to another plant or in a small pot you may notice the leaves getting marked. Propagation is easily achieved by removing a leaf from a rosette and allowing it to callus over. When it starts to root, it can be potted up.

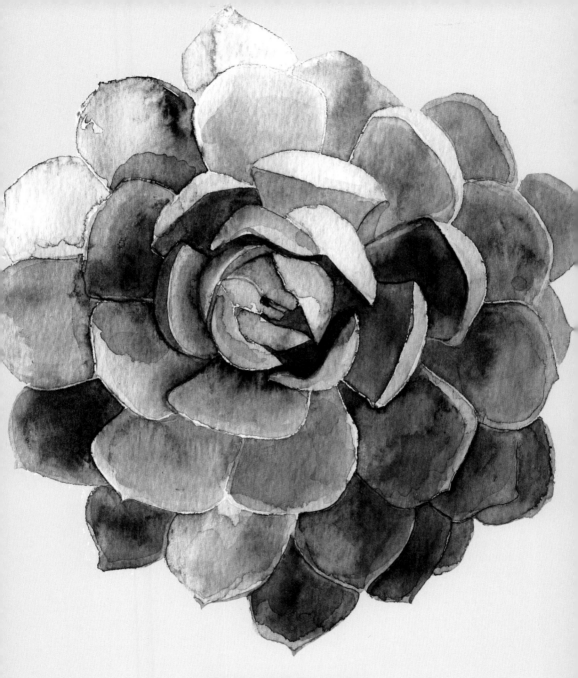

PAINTED LADY

ECHEVERIA DERENBERGII

Echeveria nodulosa
Painted Echeveria
Mexico

This highly decorative echeveria can easily be recognized from its fleshy, pointed, olive leaves painted with bright red on the margins and in the centre. Like most echeverias, this species forms a parent rosette, which offsets quickly to produce clumps of foliage. Emerging from the centre of a rosette, a long, arching stem will carry beautiful, dusky pink flowers in the summer months.

The painted echeveria enjoys a mix of bright sun and light shade throughout the day. Although it is relatively frost tolerant, it is advisable to bring plants inside during the winter months, as next season's bloom will be enhanced if plants are protected from the bitter cold.

Water moderately, once a week, throughout the summer months when flowering, but allow the compost to dry out completely between waterings. Through the winter, when the plant becomes dormant, water just enough to prevent the leaves from withering.

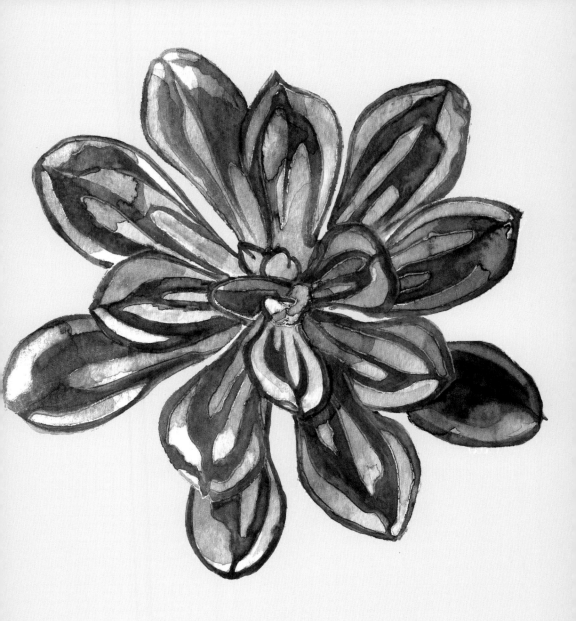

PAINTED ECHEVERIA
ECHEVERIA NODULOSA

Haworthia margaritifera
Pearl Plant
South Africa

These small succulents are often compared to aloes, with the white tubercles covering the backs of the leaves giving a pearly appearance. Usually very small and very slow growing, haworthia is perfect as a low-maintenance plant. The pearl plant will usually flower during summer, a few weeks after the longest day of the year. However, the flowers are rather dull and insignificant, and the plants are grown for their attractive leaves. Thriving in indirect sunlight, these small and dainty plants look great grouped together with other succulents and rarely outgrow their containers so repotting is infrequently required.

Pearl plants will survive on watering once a month but will thrive if you water once every two weeks in the growing season. However, overwatering can cause root rot and can be highly detrimental. Allow the surface of the compost to dry out between waterings, and water much more sparingly in the winter months.

PEARL PLANT

HAWORTHIA MARGARITIFERA

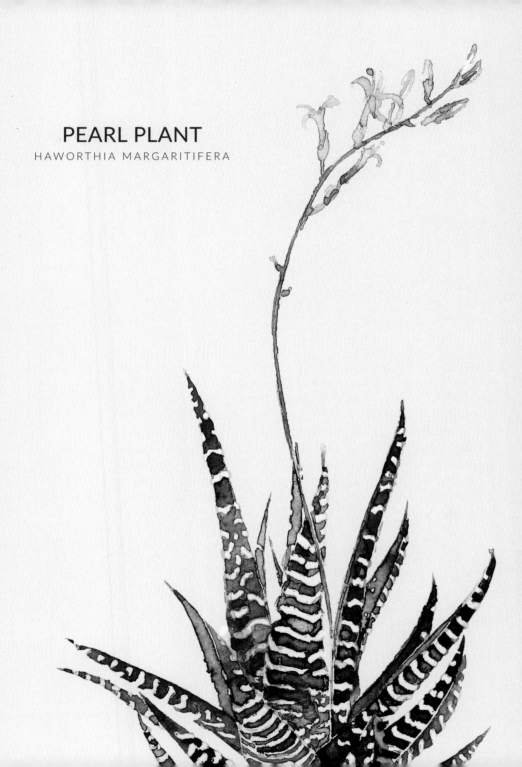

Hoya carnosa
Wax Plant
Yunnan Province, China

A creeping evergreen perennial, the wax plant has fleshy leaves with collections of waxy pink flowers that should appear from late spring to late summer, becoming more beautiful with age. Growing up to 3 m/10 ft it is suggested that you support hoya using a trellis or bamboo rods. Wax plants may also develop aerial roots that shoot out for extra stability as they grow.

Quite a temperamental plant to grow in the home, the wax plant responds well to bright sunlight and a liberal amount of water through the summer months. Try not to move the plant once it has started flowering or the buds may fall off. Do not remove the dead flowers as new flowers will arise from these next season.

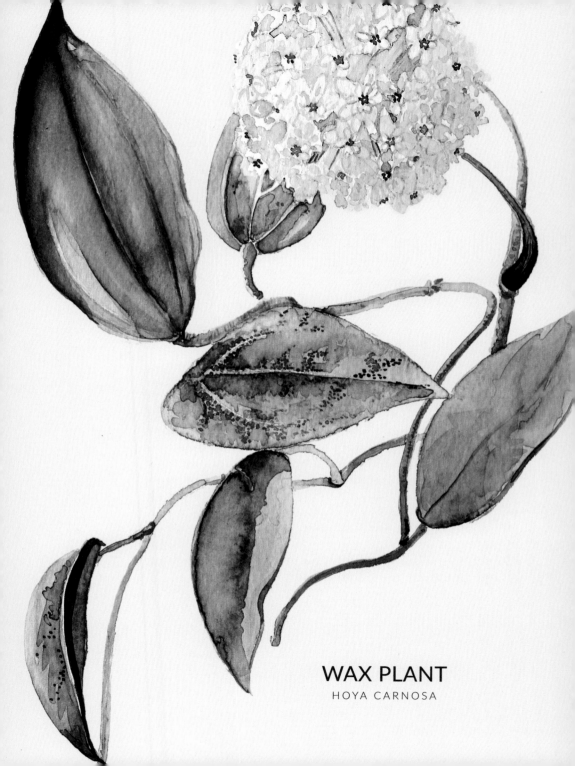

WAX PLANT

HOYA CARNOSA

Kalanchoe tomentosa
Panda Plant
Madagascar

This fuzzy, mint-green succulent, with its silvery, oval leaves and rusty brown tips, is one of the more attractive kalanchoes chosen to grow as a house plant.

Happy in a sunny window, the fleshy leaves of the panda plant mean that it can survive periods of drought and neglect. During the active summer growth period water sparingly, just enough to keep the soil moist, and allow to dry out completely between waterings. During the winter rest period you should water even less frequently, just sufficiently to ensure that the leaves do not shrivel. Overwatering the panda plant can mean that the leaves become overly large and flabby and eventually they will rot.

Propagating can be achieved easily by leaf cuttings. You can remove these in spring and allow them to callus on a dry bed of potting mixture. As soon as you notice the leaf start to form roots, place in a gritty compost and water only when the plant becomes established.

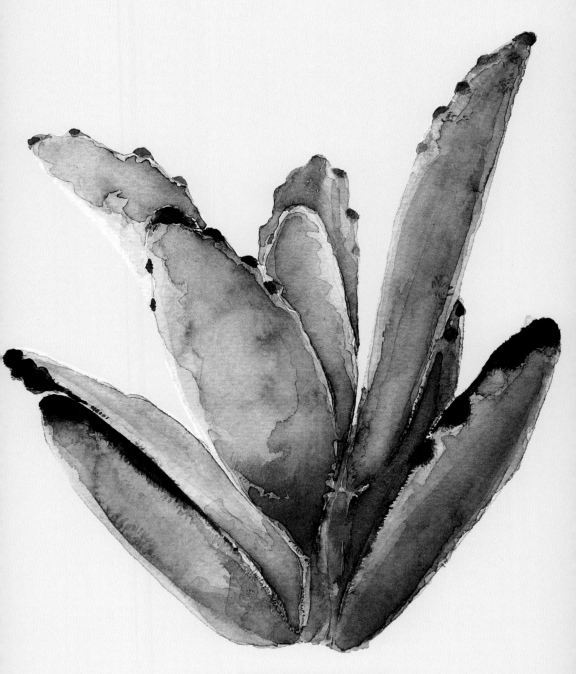

PANDA PLANT

KALANCHOE TOMENTOSA

Lithops
Living Stones
Philippines

Mimicking the rocks and pebbles that surround them in their desert-like habitat, lithops have a short underground stem that grows a pair of fleshy, semi-circular leaves. These leaves grow very slowly and without much change, so much so that they have been named living stones. The upper surfaces of the leaves can be plain, others are patterned with different tones and grains. The leaves are fused together until near the surface where you will see a split in the leaves. It is from this split that during late summer and early autumn you may get a single, daisy-like flower. After lithops have flowered the old leaves wither and die back as a new pair emerges to replace them.

Throughout the year living stones favour at least a few hours of direct sunlight; placing them in a warm environment will also help to encourage flowering.

From late spring to early autumn water sparingly, allowing the soil to dry out completely between waterings, and then water only so that the soil feels slightly moist. Over the winter months the plants go into a rest period. The old leaves will give the new leaves enough moisture to survive throughout this period and watering can prove fatal – the plants will need no extra water until the following season.

Propagate in the early summer months by separating out the clumps of stones and re-potting into a gritty soil mixture, make sure to give plenty of sunlight during the first few weeks.

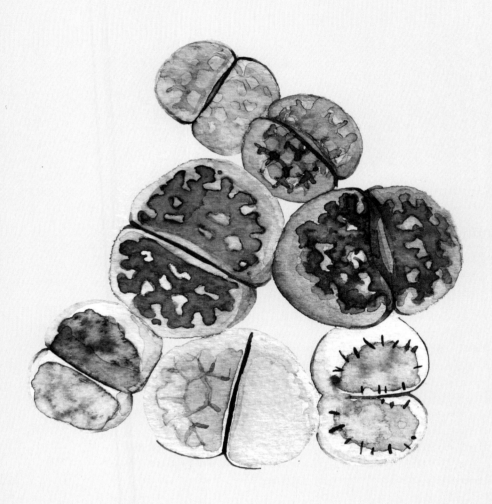

LIVING STONES

LITHOPS

Sedum morganianum
Burro's Tail
South Mexico

The burro's tail has become one of the favourite succulent perennials recently. With its small, bulbous leaves lining the many trailing stems, this plant looks quite alien but is perfect for a hanging basket.

These plants enjoy direct sunlight to enhance their growth and strengthen their leaf colour. Water moderately through the growing season, but in winter you should keep watering to once every few weeks. During the summer you may also be lucky enough to see some starry, deep pink flowers appear at the end of the stems.

If you move these plants around you must be especially gentle as their leaves can fall off at a single touch. However, these causalities can easily be propagated by placing them in dry soil until they start to root.

BURRO'S TAIL
SEDUM MORGANIANUM

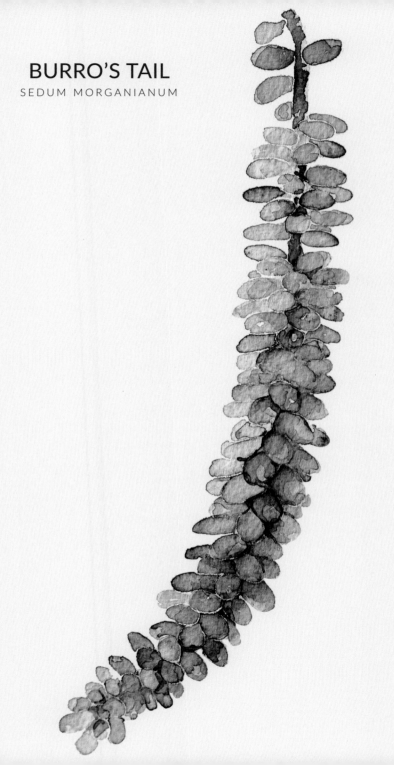

Senecio radicans
String of Bananas
South Africa

The long tendrils of banana-like leaves easily identify *Senecio radicans*. The leaves also feature partly transparent sides which allow as much sunlight to shine through the plant as possible.

This succulent is relatively hardy and easy to grow, which makes it ideal for beginners growing in their home. Although grown mostly for the texture of the foliage, during late winter or early spring you may be lucky enough to witness the small, cinnamon-scented, white flowers of this plant.

A fast-growing succulent with stems reaching as long as 1 m/3 ft, *S. radicans* is an ideal plant for a hanging basket. The string of bananas thrives best when given the occasional trim.

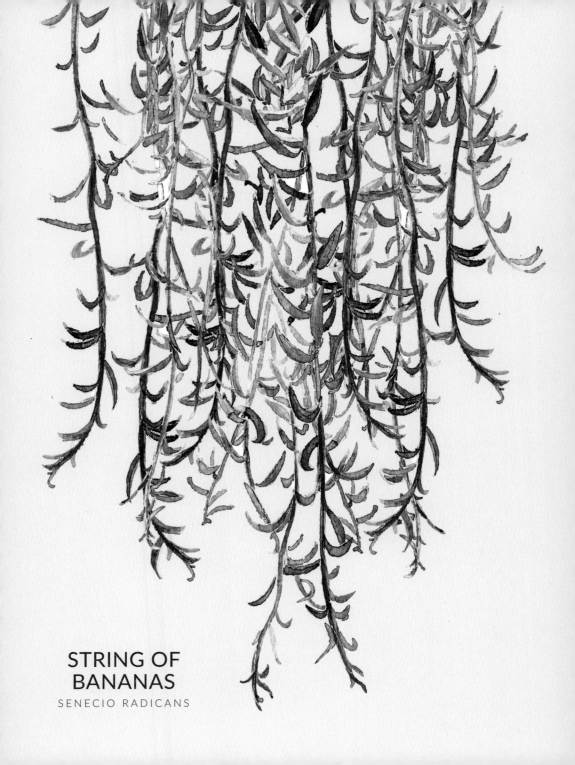

STRING OF
BANANAS
SENECIO RADICANS

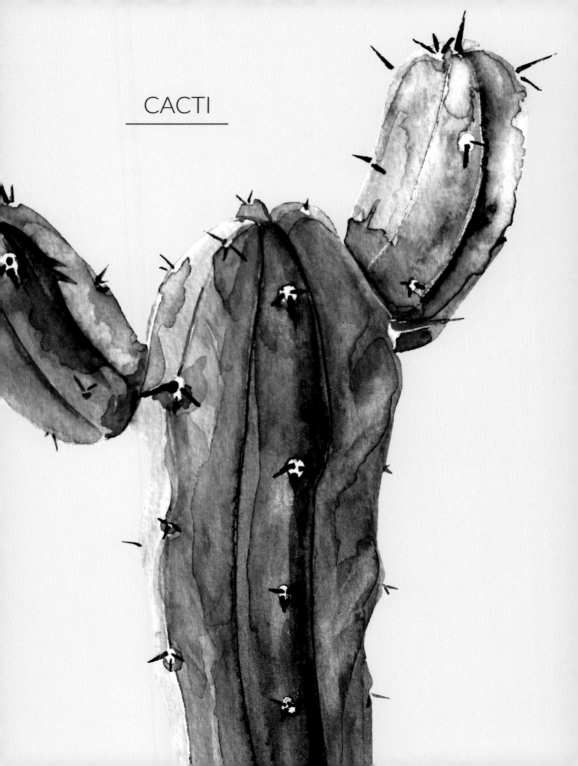

CACTI

Austrocylindropuntia subulata
Eve's Needle
South America

When looking at its cylindrical green leaves it becomes clear where the Eve's needle cactus got its name. Growing up to 4 m/13 ft, this tree-like cactus possesses a similarity to the smaller string of bananas plant. Like most cacti that are native to arid and desert conditions, Eve's needle is pretty self-sufficient in the home, needing watering once a week during the summer but then much less frequently in the colder months. Position the plant where it will receive plenty of light. The overall appearance of Eve's needle could lead you to categorize it as a succulent rather than a cactus; however when you look more closely you will notice the light yellow spines. During the summer it may produce bright red flowers that emerge from the tips of the leaves.

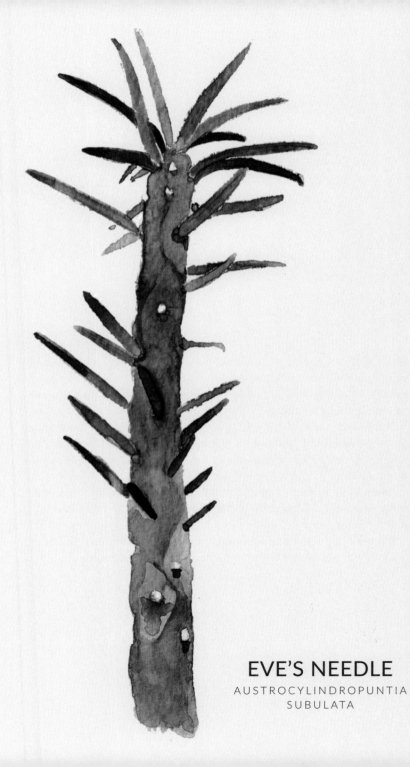

EVE'S NEEDLE

AUSTROCYLINDROPUNTIA
SUBULATA

Chamaelobivia
Peanut Cactus
Hybrid origin

This is a clumping cactus with small, peanut-sized bodies that can group up to thirty at a time. When they all flower simultaneously it becomes quite an amazing sight – a flurry of bright pink and red or yellow flowers. Various named varieties are available.

The peanut cactus is an easy-to-grow plant that is suited to hanging baskets as well as pots. It enjoys full to moderate sunshine and in many places can even be left outside all the year, as it is resilient to temperatures as low as -8°C/18.5°F.

Water once a week throughout the summer months and then stop watering completely during the cooler winter months, as it can be prone to root rot during this time.

It is a very easy plant to propagate. When one peanut offsets, this can be removed and placed on a dry bed of compost until it starts to root.

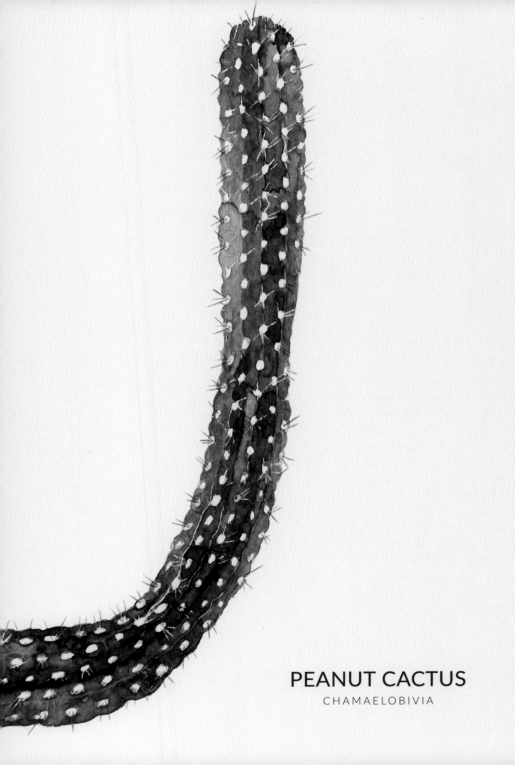

PEANUT CACTUS

CHAMAELOBIVIA

Coryphantha elephantidens
Elephant's Tooth
Mexico

A large, globular cactus that will form clumps with each head growing up to 18 cm/7 in diameter, elephant's tooth is one of the larger cacti you could chose to have as a house plant. The very sharp radial spines grow to the curvature of the cactus's tubercles, some of which are fluffy with woolly white hair.

Appreciating full sunshine at all times, this cactus will make healthy and robust growth on a sunny windowsill. Even with copious direct sunshine, however, this is a very difficult plant to bring into flower in the home. If you are lucky enough to have success, the flowers are large, pink and very showy.

Coryphantha needs minimal watering. During the summer months once a week will suffice, but during the winter you should refrain from watering at all.

One thing to be aware of is the sticky sap that is secreted from the nectary glands. This should be removed straight away, as it will develop a sooty black mould, which can prove really unsightly.

ELEPHANT'S TOOTH

CORYPHANTHA ELEPHANTIDENS

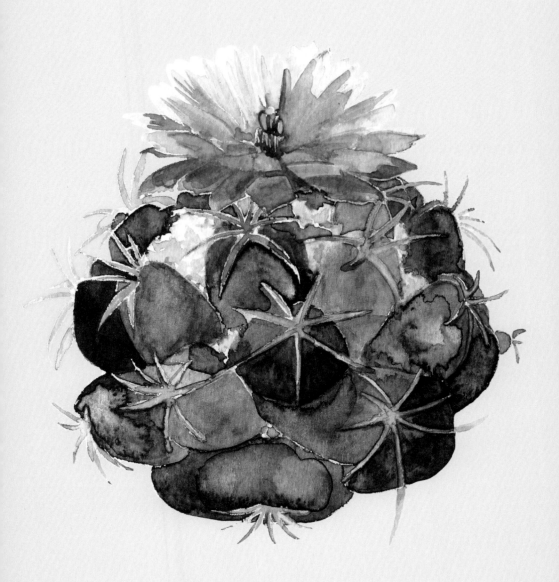

Cryptocereus anthonyanus
Fishbone Cactus
Mexico

An ornamental trailing cactus that comes into its own when potted in a hanging basket or left to meander off a shelf, there really is nothing else quite like the fishbone cactus. It is an epiphytic plant, and grows hanging from trees in its natural conditions. Pot the fishbone cactus in a gritty, free-draining mixture. Unlike most cacti it will thrive with summer humidity and can be grown in semi shade or full sun. Extra sun in the early spring will promote flowering.

Throughout the summer months make sure that the potting mixture is kept just damp at all times, but do not allow the pot to sit in a tray of water as this can easily bring on root rot. Through the winter months, do not allow the temperature to drop too much and keep watering to a minimum.

The fishbone cactus enjoys a small pot and should be repotted only when it has completely outgrown its current container. The pale pink, short-lived flowers will only appear on mature and root-bound plants.

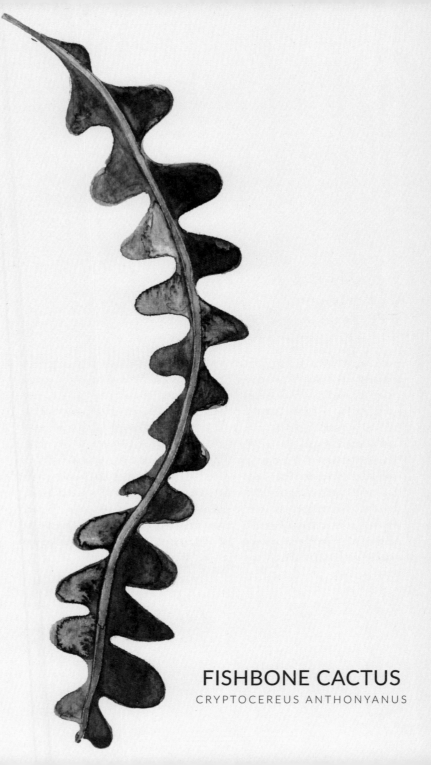

FISHBONE CACTUS

CRYPTOCEREUS ANTHONYANUS

Euphorbia ingens
Candelabra Tree
South Africa

In its natural habitat the candelabra tree becomes a tall-standing specimen with a rounded crown that makes it look almost like a hot air balloon. With its spines running along the edges of branches and flowers running uniformly along the top of most segments this plant holds a position of beauty within the cactus world. It is easy to grow and will provide a welcome addition to any succulent and cacti garden. 'Ingens' means 'huge', and in the right conditions this plant is one of the larger cacti, mainly witnessed in arid landscapes of California. However, it can be grown successfully in pots in the home, where it assumes more of a branching candelabra shape. When potting, make sure that the soil is completely dry to avoid root damage. It is a fast-growing plant and may soon outgrow even the largest pots. It is very easy to propagate by pruning off a limb and allowing the end to dry out for a few days before placing it in a sandy soil.

CANDELABRA TREE

EUPHORBIA INGENS

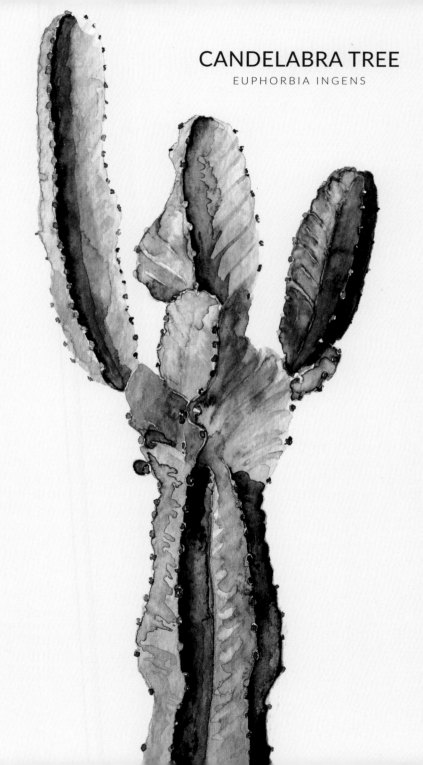

Euphorbia milii
Crown of Thorns
Madagascar

A dense, shrub-like plant that can grow up to 1 m/3 ft tall, this is a cactus that at first does not really appear to look like one, until you see the threat of the short, sharp spines that line the stems. Clusters of small, oval green leaves are carried on the stems, and the lower ones tend to drop after a few months, leaving the base of the stems bare. Bright red flowers are freely carried in spring and summer.

The crown of thorns likes plenty of light, but should be shaded from strong, direct, midday summer sun. Do not be shy about direct sunlight in the winter months, however.

In the summer months, water thoroughly once a week, but do allow the compost to dry out in between waterings. During the winter months water much less frequently; once every few weeks will suffice.

Propagation can be achieved by taking stem cuttings in spring or summer, allowing the cuttings to dry slightly for a few days before placing them in a potting mixture. Be aware of the sharp spines though; wear gloves as this can be a prickly job.

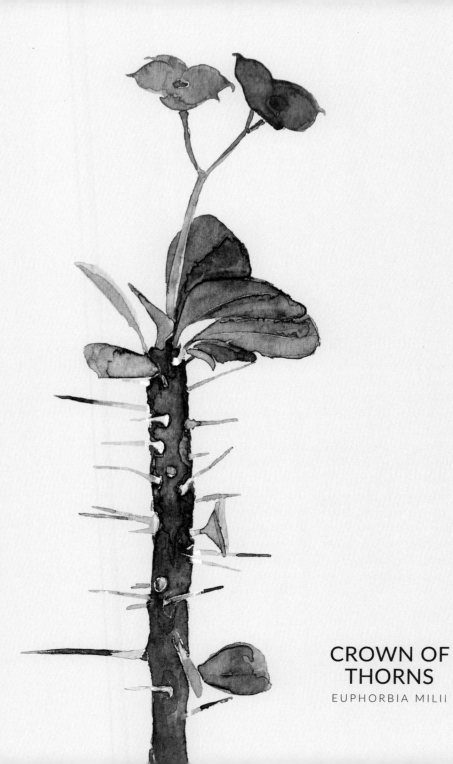

CROWN OF
THORNS

EUPHORBIA MILII

Euphorbia tirucalli
Pencil Cactus
Africa

A native African succulent tree, this cactus is easy to grow in your home. If it is well cared for you will bear witness to the bright green to red stem colour change, which occurs in its natural environment in times of intense sunlight or drought. Place the plant in a position that will give it a few hours of daily sunshine.

Pot in a gritty, well-draining potting mixture; it is advisable to use an unglazed clay pot which will allow excess moisture to evaporate.

Tolerant of drought, throughout the summer months the pencil cactus will need watering only every two to three weeks. As the weather cools in the winter months you should cease watering completely as the plant will enter a state of dormancy at this time and watering can easily promote root rot. Only water slightly if you notice any of the limbs starting to wither at the ends.

Be aware that if a limb breaks it will secrete a white milky sap that can be toxic to animals and a skin irritant to humans.

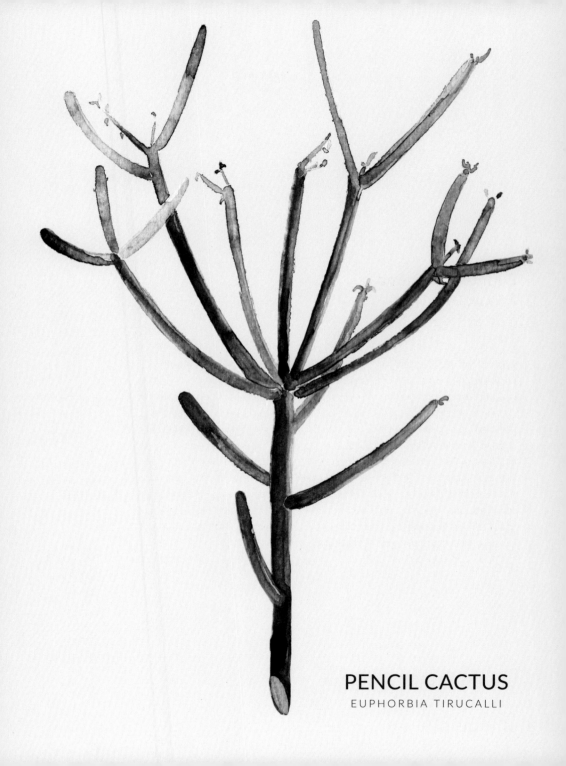

PENCIL CACTUS

EUPHORBIA TIRUCALLI

Euphorbia trigona
African Milk Tree
Central Africa

With a slim, upright stem that will branch into four or five separate stems, this could be one of the daintiest cacti that we are looking at. A hardy plant that can withstand temperatures down to -3°C/26.5°F, the African milk tree is usually seen only as a house plant, as it rarely occurs in nature any more. Although it is hardy, it will perform much better if you make sure you do not expose it to freezing conditions. Put its pot in a position with free air circulation, as it does not cope well with high humidity. The plants need watering only two or three times a month. One problem that you may encounter with your African milk tree is that because of their height and small root structure, these plants have a tendency to topple over. When handling the plant, be sure to wear protective gloves as even the smallest amount of its toxic, latex sap can cause skin irritation.

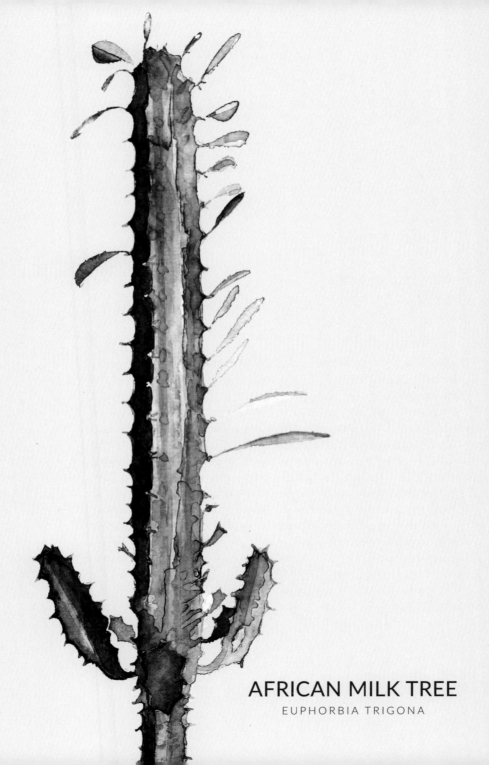

AFRICAN MILK TREE

EUPHORBIA TRIGONA

Ferocactus gracilis
Fire Barrel Cactus
Mexico

This bright barrel cactus, with a round, globular body and bright red spines, is a short, stout, solitary plant that grows slowly in cultivation. Be aware of the sharp hook at the end of some of the spines.

In the wild, plants are exposed to full sunshine throughout the day, and to ensure the spines take on a good, intense red colour in the home, make sure that the cactus gets as much direct sunlight as possible all year round. In mild climates, if warm enough, you can even leave it outside during the late spring and summer months, and let it bask in the direct sunshine.

Pot in gritty, free-draining compost. Ferocactus does not do well in humidity so make sure that you place it in a cool, airy position. Throughout the active summer growth period, water moderately once a week, each time ensuring that the compost has dried out between waterings. During winter, water much more sparingly. Never allow water to sit on the body of the cactus as this can damage it.

Because ferocactus do not grow pups or offsets, propagation can only be carried out by growing from seed.

FIRE BARREL CACTUS

FEROCACTUS GRACILIS

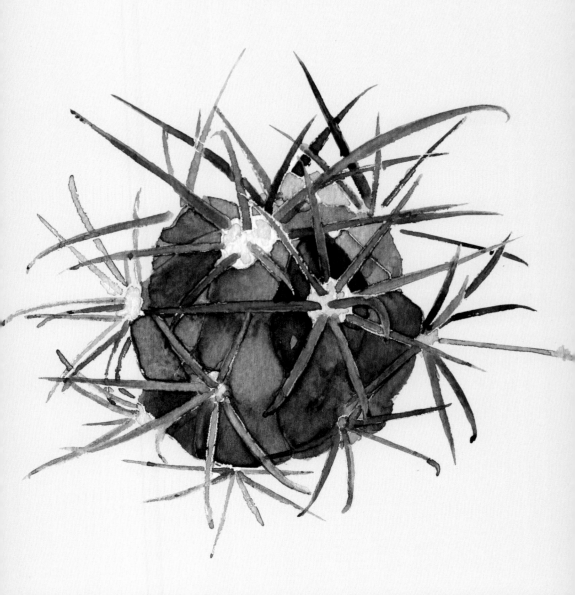

Gymnocalycium bruchii
Naked Bud
Argentina

One of the most cold-tolerant cacti, the naked bud will survive most conditions and is very tolerant of neglect. It is characterized by the lack of spines or hair on the flower bud, hence the name 'naked bud'. It has a small body that produces offsets quickly to form large, flat clusters.

Although it will tolerate a wide range of growing conditions this plant will thrive best in full sunshine, though it will appreciate a little afternoon shade during the hottest summer months. Plenty of sun will enhance the chance of pink blooms being produced during the spring and summer months. Water regularly in the summer months but much more sparingly in winter. Allow the compost to dry out between waterings.

The naked bud can be propagated by separating the offsets and leaving them on dry compost until roots start to form, when they can be potted up.

NAKED BUD

GYMNOCALYCIUM BRUCHII

Lepismium bolivianum
Hang Cactus
Bolivia, South America

With many branched stems that will grow off of a central stem, *Lepismium bolivianum* plants tend to look like a dangerously sharp mass, but this appearance is at once softened when they are flowering. The flat stems are then decked with white, pink and slightly orange flowers. These cacti will enjoy a hanging basket to enable them to let their branches hang freely. Partial to light watering and full shade, they need little fussing. Water freely in spring, around once a week; however during the winter months allow the compost to completely dry out before watering again.

They are very easy to propagate; take a cutting from one of the woody stems and allow the base to callus over until it starts to root.

HANG CACTUS

LEPISMIUM BOLIVIANUM

Myrtillocactus geometrizans
Blue Candle Cactus
Mexico

This semi-hardy cactus has wide blue-grey stems which branch to form a dense, candelabra-like tree. Short spines are formed in groups of three or four from the aureoles and usually only grow up to 2 cm/¾ in length. They are spaced evenly along each of the outer ribs.

Young plants should be given light shade in the home but more mature plants will require ample and direct sunlight, which will also encourage flowering and fruiting. Water once a week during the summer months but in the cooler winter months, water only if necessary to ensure that the branches do not shrivel.

As with all cacti the blue candle cactus should be planted in gritty compost. When repotting, make sure that the roots are well firmed in, as this cactus can quite easily get top heavy and topple over.

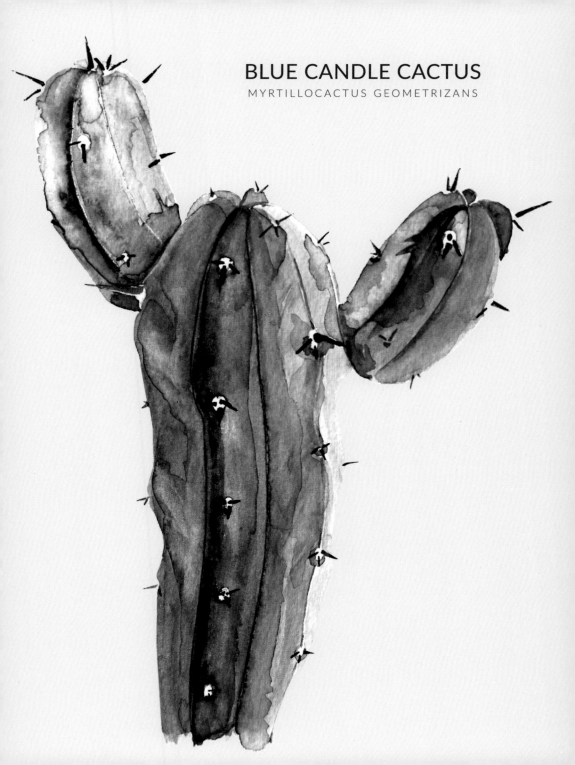

BLUE CANDLE CACTUS

MYRTILLOCACTUS GEOMETRIZANS

Opuntia microdasys 'Albata'
Bunny Ears Cactus
Mexico

One of the most widely distributed cacti, this is a very popular plant with its flat, furry, branching stems. A spineless cactus, bunny ears is adorned with yellow and white areoles which are packed with tiny golden glochids. Although these look extremely pretty they are very spiky and can be a severe skin irritant.

Opuntias need as much direct sunlight as they can get throughout the year. The ideal position would be a draught-free window ledge, especially in the winter months. Bunny ears plants definitely favour a warm winter, and if the temperature drops too much around them you may start to notice brown markings appearing on the leaves.

During the actively growing spring and summer months, water plants moderately, enough to moisten the potting mixture thoroughly, but allow to dry out again completely before the next watering. These cacti can tolerate a lot more water than most, and will wilt in the summer if they are too dry. Through the winter months you should water much more sparingly.

BUNNY EARS CACTUS

OPUNTIA MICRODASYS 'ALBATA'

Pachycereus marginatus
Mexican Fencepost Cactus
Mexico

With slim columnar trunks, the Mexican fencepost cactus stands tall and straight in its native environment. From its central spine protrude up to nine radials, which are sometimes yellowish in colour. Once established, these magnificent cacti can grow untouched for decades as long as they are receiving adequate amounts of sun and heat; water during the summer months, especially while the plant is young, but let the compost dry out between waterings. When repotting, be sure not to have the compost too moist, as this will promote root rot.

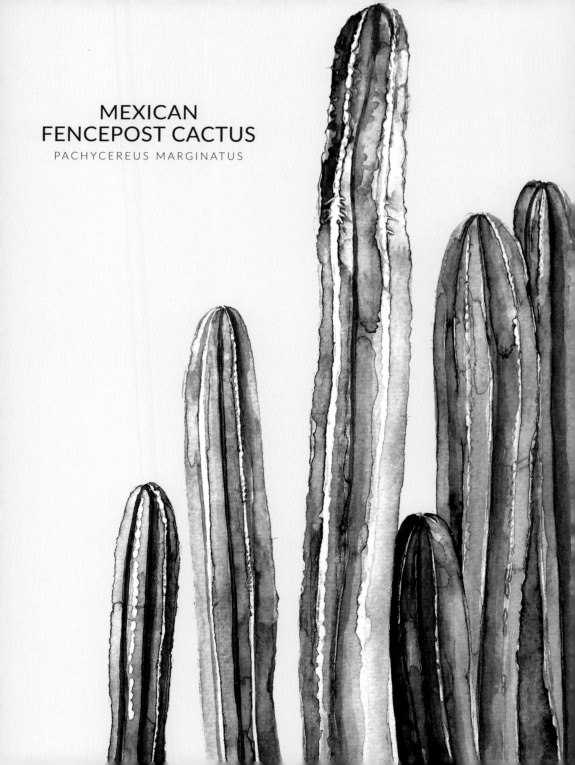

MEXICAN
FENCEPOST CACTUS

PACHYCEREUS MARGINATUS

Peyote Lophophora williamsii
The Divine Cactus
Texas and Mexico

This small, spineless cactus has been a very important figure in various religious rites throughout many Native North and Central American cultures for many years. It contains large amounts of mescaline, well-known for it's psychoactive properties. The plants are often known as button cacti due to their tiny, spherical appearance above the surface of the soil – quite sweet and unthreatening compared to their spiky siblings. Each plant has a large mother root, so when repotting, use a deep pot to accommodate the root comfortably. Preferring a shady spot to direct sunlight, these cacti can survive the driest of conditions; the more bulbous the shape of a cactus, the more water it can retain inside. During the summer months the divine cactus will produce a cluster of white or pink flowers from the centre. The mescaline it contains means the usage of this cactus has often been abused, though it has also been used for medicinal purposes.

THE DIVINE CACTUS

PEYOTE LOPHOPHORA WILLIAMSII

Schlumbergera Buckleyi
Christmas Cactus
South America and Mexico

In their natural environment, schlumbergeras grow in damp pockets of leaf debris in tree branches; when growing at home, try as best you can to replicate these jungle-type conditions. The densely branching stems arch outwards in flat, wide, green segments, with an almost serrated edge. The segments are lined with small, bristly areoles. It is from the final areole of each stem that the bright pink and red flowers flourish throughout the winter months.

Although they enjoy the early morning or late afternoons sun, like many cacti, schlumbergeras need to be shielded from direct, strong sunlight. From early spring up until late autumn place them on a lightly shaded windowsill. The less intense winter sunshine should be fine for them. They will also enjoy being placed outside during the warmer summer months, and a spell outdoors will encourage them to bloom later in the year; just make sure that they are brought inside before the temperature drops as cooler weather approaches.

Throughout most of the year it is important to water enough to keep the potting mixture constantly moist. During the period after flowering the plant needs to rest, keep watering to a minimum. Schlumbergeras will appreciate the use of rain water much more than tap water, as they are intolerant of hard water.

CHRISTMAS CACTUS

SCHLUMBERGERA BUCKLEYI

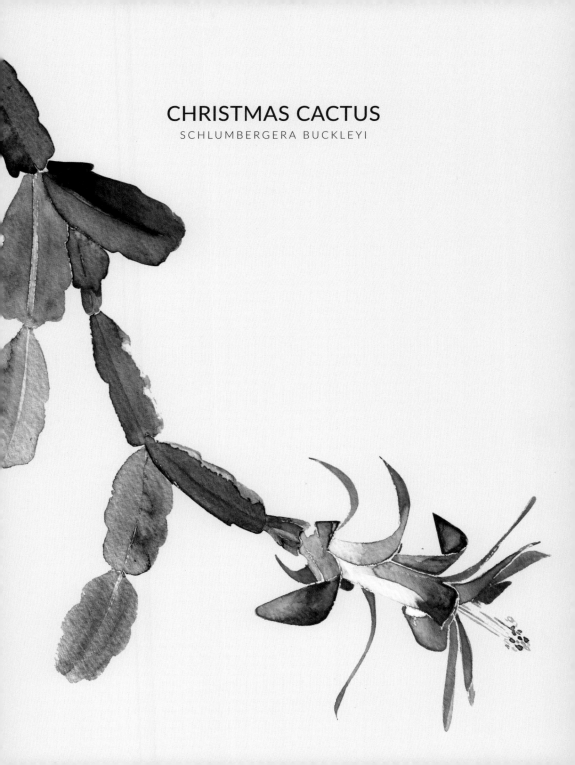

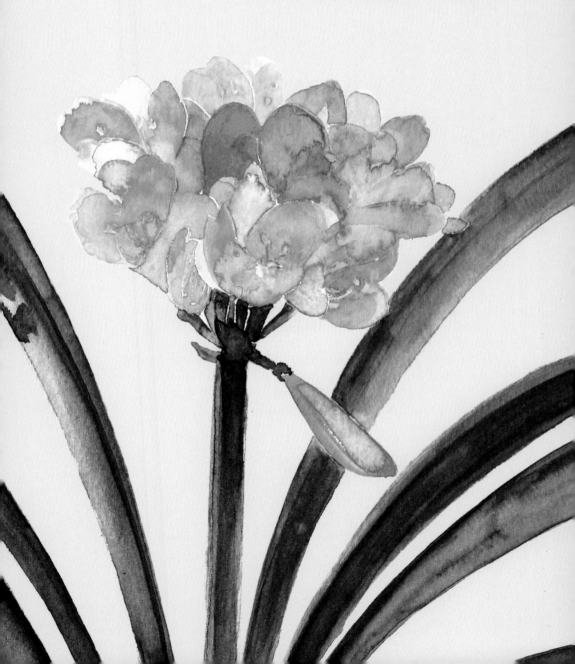

FLOWERING PLANTS

Anigozanthos manglesii
Kangaroo Paw
Australia

This captivating plant has become available as a house plant in the past few years, but it is still quite unusual to see it in the home. Despite its tropical appearance it does well in relatively cool, shady conditions and likes a dry atmosphere – misting is not necessary. The unusual woolly flowers that tower over the grassy foliage have a seeming resemblance to the feet of a kangaroo, giving the plant its common name. In its natural habitat their bright red colouring is strongly attractive to birds and wildlife. Grow in free-draining compost in a bright, airy position and allow plenty of space as the flowers can be tall, reaching up to 1.5 m/5 ft. Keep the compost just moist through the growing season but water more sparingly in winter.

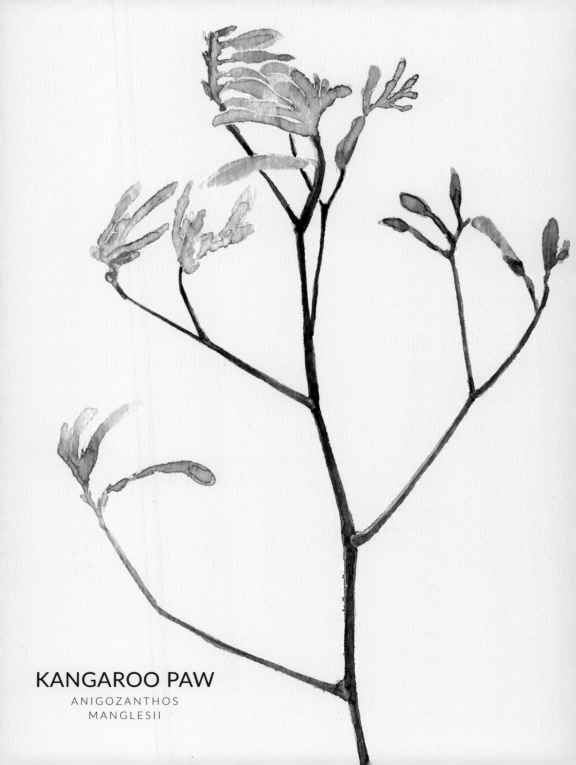

KANGAROO PAW

ANIGOZANTHOS
MANGLESII

Anthurium scherzerianum
Flamingo Flower
Mexico

There are over 500 species within this genus, but few that seem to live well in the home; however, the flamingo flower is one of the best. An easy plant to distinguish with its showy, bright red, waxy flower spathe and central tail, it can easily be mistaken for an artificial flower, as each inflorescence is very long lasting.

These plants can be quite a struggle to grow; they need moist, humid conditions and ample light (but not direct sunlight) as well as freedom from draughts. You will generally need to repot your flamingo flower every spring. The plants need well-drained conditions so make sure that you choose a suitable free-draining compost when repotting. Caring for your anthurium may be a challenge but it will definitely be worth the time and dedication – seeing the spectacular flowers emerge from beneath the dark green leaves is very rewarding.

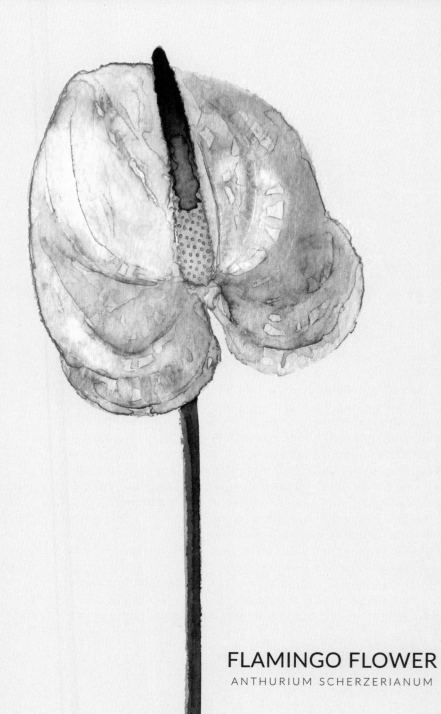

FLAMINGO FLOWER

ANTHURIUM SCHERZERIANUM

Begonia coccinea
Angel Wing Begonia
Brazil

The angel wing begonia is one of the largest in the genus, reaching up to 2 m/6 ft or more if it is left unpruned. It is now often grown indoors at eye level, so that people can appreciate the lovely red colouring on the underside of the leaves.

Keep Begonia coccinea out of direct sunlight, in an environment that is not too dry. A small amount of morning sunlight and then shade throughout the remainder of the day will be perfect – direct sunlight can easily scorch the leaves. From spring to autumn you will need to water your angel wing begonia regularly, and occasional misting will increase the humidity around the plant which it will thank you for as well, especially whilst it is in bloom.

During the winter months decrease the watering and water only when the top of the soil has completely dried out; begonias can really suffer if they are overwatered. In early spring the shoots can be pruned back lightly to encourage the plant to become more bushy.

This begonia will bloom throughout the summer months, producing pendulous clusters of small, waxy flowers that can range from a light pink to bright red. These will die back very quickly if the compost becomes too dry.

ANGEL WING BEGONIA

BEGONIA COCCINEA

Ceropegia woodii
String of Hearts
South Africa

A tube forming trailing plant with dainty dark green and lilac heart shaped leaves that cascade in pairs down the stems, the Woodii is a popular houseplant which is easy to grow and looks highly impressive in a small hanging pot or basket. Each stem can reach up to 1.2 m/4 ft long, and during the summer months you may witness the long, thin, tube like white and purple flowers emerging from the leaf nodes.

Needing at least 3 to 4 hours of direct sunlight every day in order to enhance the leaf colour, the String of Hearts will thrive hanging near a window; happy in normal room temperatures just make sure that the Ceropegia is not near a cool draught.

During the active growth and flowering season water sparingly, the Ceropegia is a succulent plant so its stores water in its leaves, during this time it will only need enough to ensure that the potting mixture is slightly damp. During the winter rest period, decrease water even more, only watering to prevent the leaves from shriveling.

Can be easily propagated at any time during its growth period, you will notice towards the ends of the stems new growth will appear, these can be easily cut off and set in a sandy potting mixture to root.

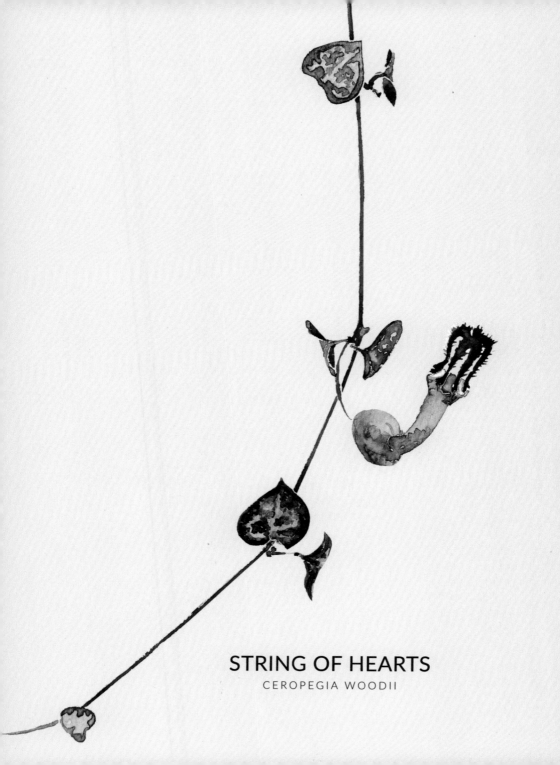

STRING OF HEARTS

CEROPEGIA WOODII

Clivia miniata
Bush Lily
South Africa

These popular house plants, with their strap-shaped leaves that fan out from a leek-like base, can span a width of nearly 1 m/3 ft, so it is important that they are given proper space to grow. Bush lilies flower in very early spring; you will notice the thick flower stalk pushing up from between the leaves, each stalk carrying up to fifteen trumpet-shaped flowers in vibrant reds and oranges.

During the summer months the soil must be kept moist at all times so water regularly, gradually reducing the frequency of watering as the temperature drops in autumn. From late autumn, the plants should be given a winter rest, reducing the watering so that the compost is almost completely dry, and keeping the plant in cool conditions of around 10°C/50°F. This rest period of six to eight weeks is essential for flowers to form. Begin giving more water once the flower stem starts to expand.

A bright spot with early morning or late afternoon sun will be perfect for the bush lily. Direct midday sun could scorch the leaves but insufficient sun can prevent the plant from flowering. After the plant has flowered, the trumpets will fall and fade leaving a collection of fruit; these berries should be removed in order to promote good flowering the following year.

BUSH LILY

CLIVIA MINIATA

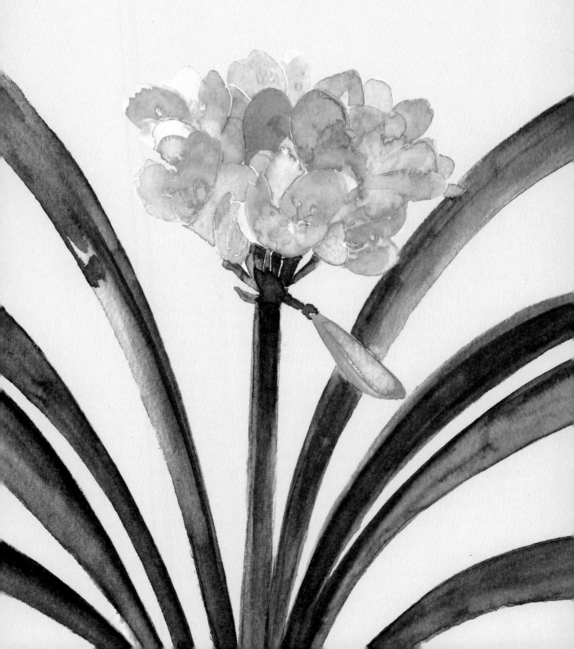

Cypripedium acaule
Pink Lady's Slipper
North America

Notoriously difficult to grow, with suitable attention and care these orchids can be kept blooming for many years. Named the Pink Lady's Slipper due to its vibrant fuchsia pocket flower which delicately adorns a long thin stem the *Cypripedium acaule* is one of the daintiest orchids you can enjoy in the home. Temperatures and humidity will need to be kept constant throughout the lifespan of the orchid, hence why you will often see them being kept in a terrarium or under a bell jar. When potted orchids should be completely free draining, they will do well in special perforated clay pots or wire baskets, the roots enjoy being subjected to sunlight so try only half filling pots with an acidic soil mixture or granules or natural clay.

In the wild, orchids will grow happily in dappled light, an epiphytic, often seen growing off of larger trees, the plant will often be shielded from any direct sunlight. This should be mimicked in the home place near a window that gets a few hours of direct sunlight a day either in the early morning or late afternoon, they may need some sort of artificial sunlight in the winter months though to ensure that they get enough light.

When it comes to watering orchids, tap water will be unacceptable due to the risk of calcium bicarbonate; collected rainwater will be the best option.

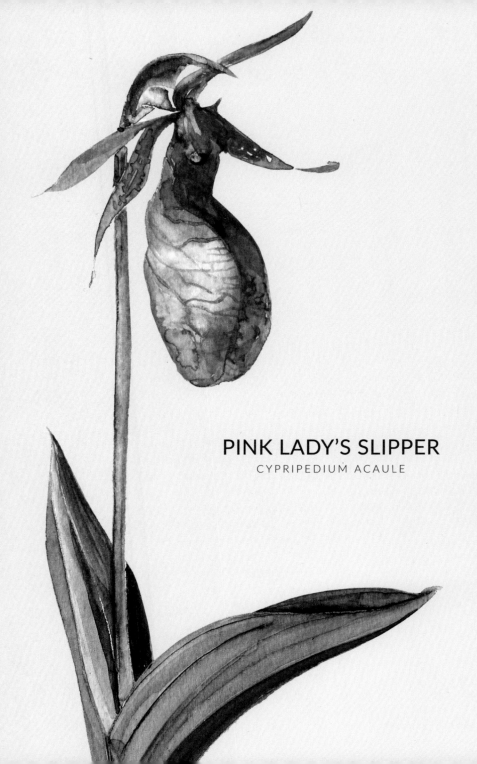

PINK LADY'S SLIPPER

CYPRIPEDIUM ACAULE

Hibiscus rosa-sinensis
Rose of China
East Asia

Hibiscus is grown for its large, showy flowers and glossy dark green leaves. The flowers form large, open, pink, yellow, white or red trumpets with a prominent central boss of stamens, and though each individual flower lasts for only a day, the flowering season is long.

Plants are best grown in large pots and should be watered freely from early spring to mid-autumn. Water until you see water coming out from the bottom of the pot but do not allow the pot to stand in water for more than a few hours as this could encourage root rot. During the cooler winter months, decrease watering to a minimum. You can keep the evergreen plants neat and tidy by pruning back some of the straggly stems and foliage in late winter.

Hibiscus will survive quite well without direct sunlight, but to encourage the beautiful flowers give your plant at least a few hours of direct sunlight every day.

Dried hibiscus flowers are edible and are often eaten as a delicacy in Mexico. They can be candied and used as a garnish.

ROSE OF CHINA

HIBISCUS ROSA-SINENSIS

Jasminum polyanthum
Chinese Jasmine
China and Burma

This is a beautiful and popular climbing house plant. Fast growing and easy to care for, jasmine will need canes, wire hoops or other supports for vines to wrap around. Plants can reach up to 3 m/10 ft high if allowed to grow unchecked, but the long slender shoots should be trained into their supports to keep the plant under control and encourage flowering. The strongly fragrant flowers are one of the main appeals of the Chinese jasmine. Pink, tubular buds open out to a multitude of small, star-shaped, white flowers in late winter and early spring.

Your jasmine will do well in sun or light shade. During the summer it will appreciate being outside in a warm spot, but bring it back indoors before the cooler winter months. Keep the compost moist at all times in the growing season. It is a good idea to mist the plant frequently to increase the humidity around it, especially when flowering.

CHINESE JASMINE

JASMINUM POLYANTHUM

Medinilla magnifica
Rose Grape
Philippines

Also known as the Philippine orchid, in its natural habitat *Medinilla magnifica* is an epiphyte, choosing to grow on trees, usually in the forks of large branches. The pendulous flowers make the plant perfect for hanging baskets. Although it is a perennial, and can often be brought into flower for two years or more, many plants are rather short lived in the home.

The pairs of glossy, thick leaves are attractive, being deeply veined with rippled edges, but the real beauty of this plant is the spectacular blooms produced in late spring. Panicles of rosy flowers form tiers separated by showy pink bracts, and are carried on long, graceful, arching stems. The plant needs a warm temperate environment, and the air surrounding it should be kept humid and moist at all times. Mist the plant frequently and keep it in a bright position but out of direct sun.

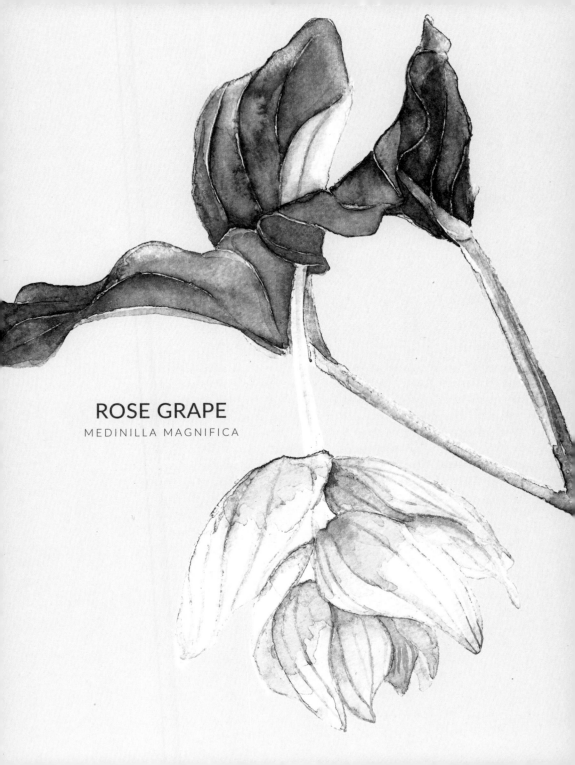

ROSE GRAPE

MEDINILLA MAGNIFICA

Nepenthes
Pitcher Plant
China, Indonesia and Malaysia

Some plants are not fortunate enough to be able to acquire sufficient nutrients from the soil so they have evolved over time to ingest insects and gain the nutrients from these instead. The name 'monkey cups' was given to these plants when monkeys were seen to be drinking water from the pitchers.

Nepenthes are among the most popular insectivorous plants to have in the home. There are several different species and hybrids available but all like similar conditions. Pitcher plants are good subjects for a hanging basket, so that their brightly coloured pitchers can hang over the sides, waiting to obtain nourishment from insects entering their lidded tubes. Once the insects are inside the container they will drown in the digestive pepsin liquid that forms a pond at the bottom of the tube.

In the home, nepenthes are great for keeping down insect pests but they will need quite a lot of care. Use a specialist compost for insectivorous plants, which must be kept constantly moist, and mist the plant regularly. It is also suggested nepenthes should be watered with rain water rather than tap water.

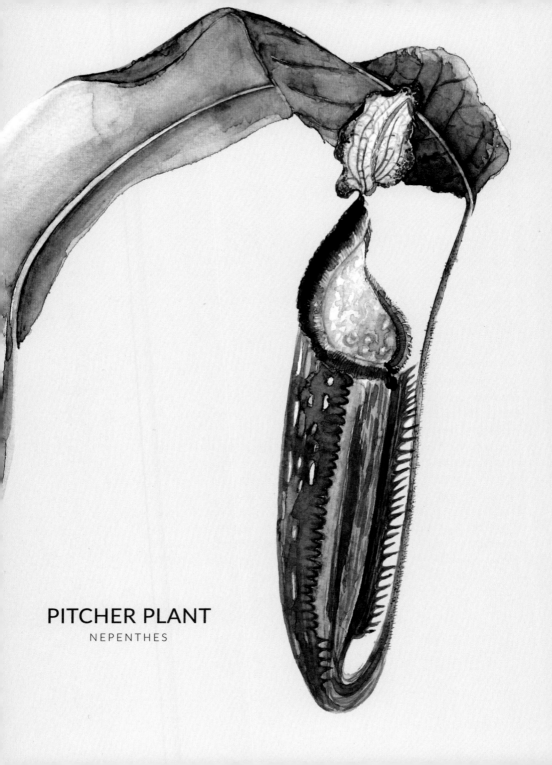

PITCHER PLANT

NEPENTHES

Oxalis tetraphylla
Iron Cross
Mexico

There are many different types of oxalis, but *Oxalis tetraphylla* is one of the most popular to grow as a house plant. The clover-like

leaves are a deep, rich purple shade and react strongly to light. During the day they open out to receive sunlight but at night they retract and fold up like miniature umbrellas, adding an interesting

touch of diversity to the plant. While the striking leaves are the main attraction, the plant also bears pretty little trumpet-shaped bright pink flowers in summer.

Oxalis grows from small bulbs and consumes lots of water in the growing season, so check regularly that the compost is moist. Take care not to leave the pot standing in water, though, as the plant needs free-draining conditions. Water very sparingly in winter. Although oxalis is sometimes used as an addition to salads for its sharp, acidic flavour it can be toxic in large amounts, and has been reported as harmful to pet cats and dogs.

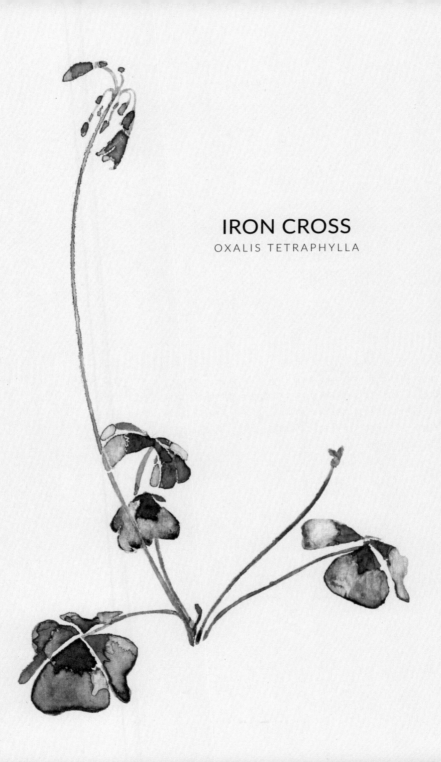

IRON CROSS

OXALIS TETRAPHYLLA

Spathiphyllum wallisii
Peace Lily
Americas and Southeast Asia

The ever-popular and beautiful peace lily has delicate, white, arum-like flowers and attractive, glossy leaves that grow directly from the compost. Keep the plant out of direct sunlight – it does best in a lightly shaded spot. It grows quickly to make a bushy plant and it may need regular repotting in spring. Water sufficiently to keep the compost just moist at all times, and mist the foliage frequently.

PEACE LILY

SPATHIPHYLLUM WALLISII

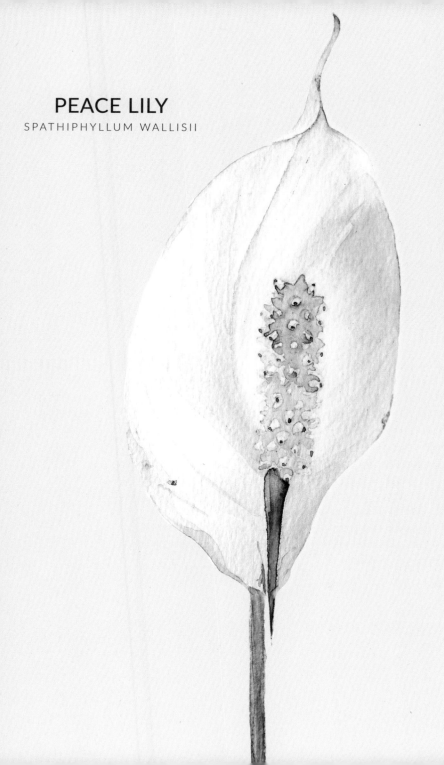

Strelitzia reginae
Bird of Paradise
South Africa

The beautiful, ornamental flowers of bird of paradise make it a popular plant, both in its natural surroundings of South Africa and within the home. This structural plant can grow up to 2 m/6 ft tall, with striking leaves similar to those of a banana plant. The vibrant orange and blue flowers are very showy, and in warm areas where the plant can grow outside the flowers make it a perfect attraction to sunbirds and weaverbirds, who enjoy perching on the stems to draw out nectar from the blooms.

Bird of paradise is rather tricky to grow in the home; in order to succeed it should be kept at a temperature of 12°C/54°F at all times, with as much light as possible. You will need patience when you acquire a new plant as it may take four to six years before the exotic springtime blooms appear. However they are well worth waiting for, and once you see them you will be enchanted by this beautifully unique plant.

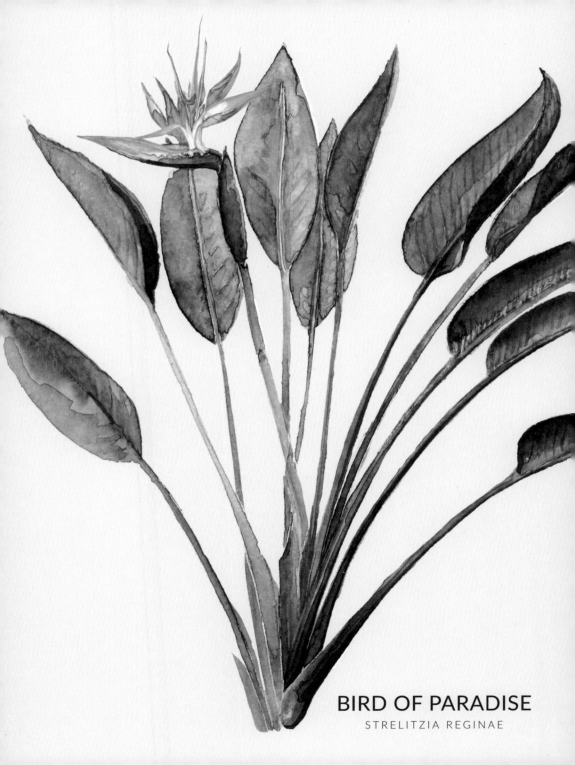

BIRD OF PARADISE

STRELITZIA REGINAE

FOLIAGE PLANTS

Adiantum raddianum
Maidenhair Fern
Tropical America

Perfect for the terrarium or a conservatory, the maidenhair fern requires a humid and shady environment. The attractive contrast between the dark, wiry stems and bright green leaves makes it a great addition to a fern collection. However, it is one of the most delicate house plants with its tissue-paper-like fronds lining the stems. This fern is quite high-maintenance when it comes to daily care. Regular misting is essential but keeping the soil thoroughly drained is also very important, as in nature these plants are usually found growing from between rocks near rivers or waterfalls. A heavy, moisture-rich compost could result in root rot.

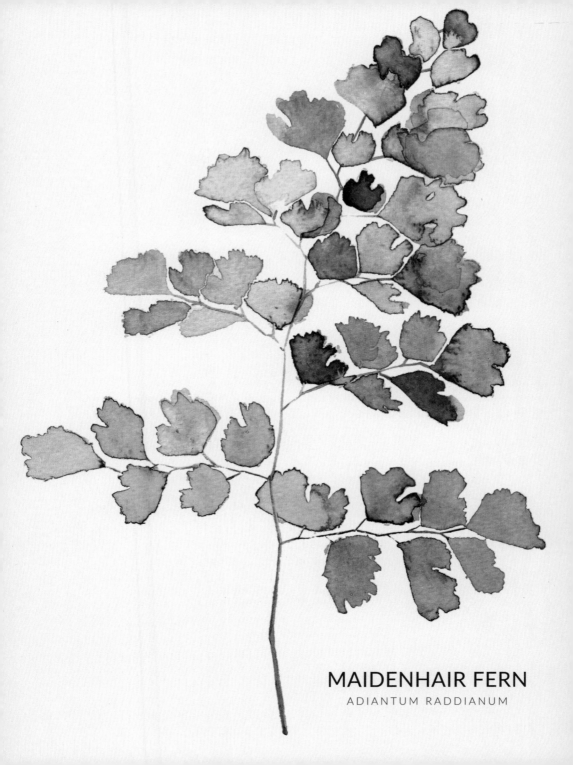

MAIDENHAIR FERN

ADIANTUM RADDIANUM

Alocasia 'Portodora'
Elephant's Ear
Hybrid origin

One of the larger house plants to have in the home, the elephant's ear produces big, ribbed, upward-facing leaves with attractively waved edges. This plant prefers full sun in the mornings and evenings, but protect the leaves from direct midday sunshine as they can easily become scorched and brown.

Water plentifully during the summer months when the compost will dry out quickly, and less frequently during the cooler winter months, but ensure the compost is kept moist at all times. Due to the size of the elephant's ear, ensure that the roots have a big enough pot to allow ample drainage of water through the potting mixture, as well as making sure the plant does not get top heavy and topple.

Although the size can be quite overbearing, placed in the corner of a large room, the elephant's ear can provide the perfect green statement.

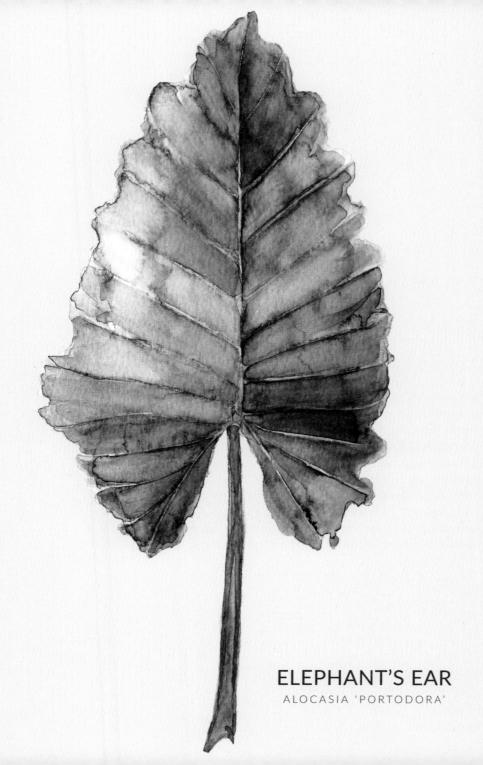

ELEPHANT'S EAR
ALOCASIA 'PORTODORA'

Alocasia zebrina

Philippines

This is quite a tricky house plant to get hold of, but its appeal lies in the distinctive, arrow-shaped leaves that stand upright on their erect, highly decorative striped stems.

Alocasia are tropical plants enjoying the warmth and humidity found in the jungle. They will survive in the warmth of a living room, but they would prefer the humidity of a bathroom or greenhouse.

Keep the compost moist at all times and mist the plant frequently. Through the warm summer months it is necessary to water once a week, but as the temperature dips in the winter, water much more sparingly.

A. zebrina is a sun worshipper, so make sure it always has quite a good amount of light, especially in the winter months when the leaves will be in need of as much light as possible.

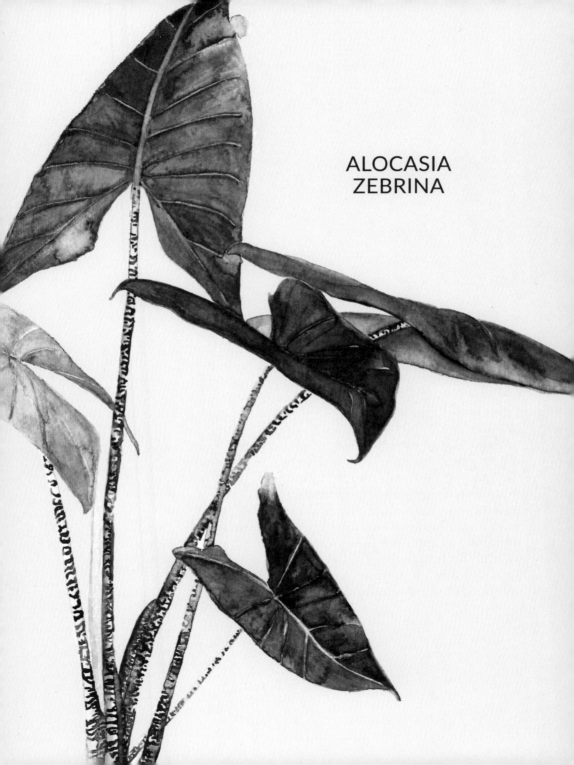

ALOCASIA
ZEBRINA

Araucaria heterophylla
Norfolk Island Pine
Norfolk Island, Australia

The Norfolk Island pine is the only pine to be able to grow indoors. It can grow up to 60 m/200 ft in its natural habitat but barely exceeds 2 m/6 ft in the home. A slow-growing pine, its branches cluster together to form fans arranged in tiers. Small seedlings of this conifer have sometimes been used in terrariums.

The Norfolk Island pine likes bright light and can withstand a little direct sun, though this is not necessary. Insufficient light may cause the needles to fall.

During the growing period from spring to autumn, water regularly, keeping the potting mixture thoroughly damp, but never allow the pot to stand in a tray of water as this can cause root damage. During the cooler winter months water thoroughly but less frequently, allowing the top few centimetres of soil to dry out before watering again. Misting the plant in heated rooms in winter is also advisable, as the dry air from the central heating can dry out the needles and cause them to fall.

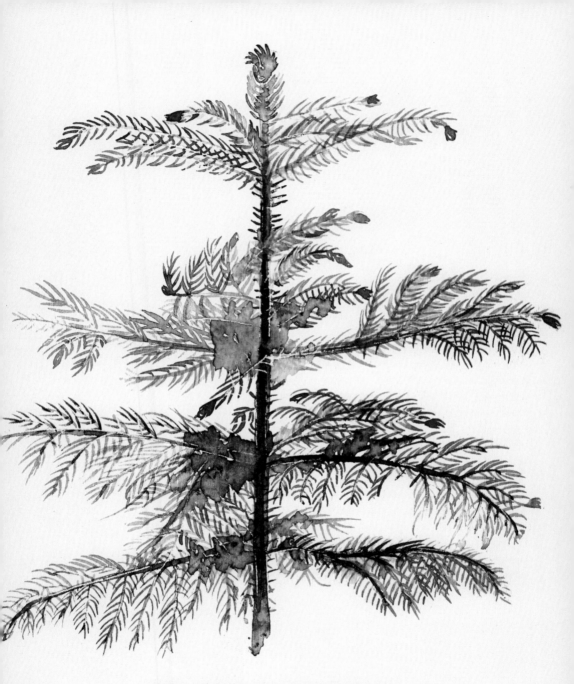

NORFOLK ISLAND PINE

ARAUCARIA HETEROPHYLLA

Aspidistra elatior
Cast Iron Plant
Eastern Asia

With long, tough, spear-like leaves, this plant earns its common name of cast iron plant due to its outrageous tolerance of neglect. It is undeterred by dust and fumes and is tolerant of almost any environment – a perfect plant for house plant enthusiasts and beginners alike.

During the summer months aspidistra should be watered freely and will enjoy a light misting every now and again. During the winter, reduce watering and do not let the roots stand in damp compost – allow the compost to dry out completely between waterings.

Position the cast iron plant in a bright and airy room, preferably with some morning sun and afternoon shade. Although it enjoys summer sunshine, do not place in direct sunlight as this can burn and brown the tips of the leaves.

Flowering is rare and infrequent, but in late spring or early summer a healthy aspidistra may produce rather curious, small, purple, bell-like blooms which cluster in groups at soil level at the base of the leaves.

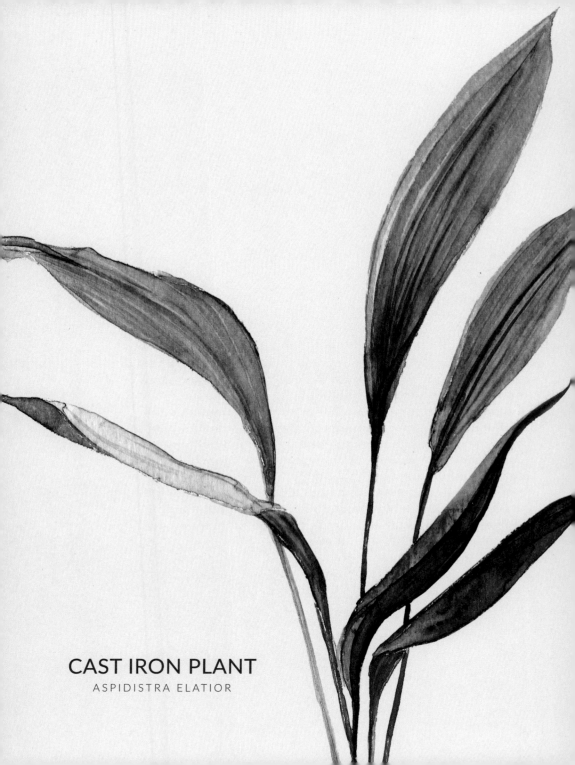

CAST IRON PLANT
ASPIDISTRA ELATIOR

Calathea lancifolia
Rattlesnake Plant
Brazil

A highly decorative plant from the Marantaceae family, the leaves of the rattlesnake plant are crinkled from the stem, light green with darker green markings on top, and a vibrant red underneath.

Growing in the tropical rainforests of Brazil, calathea will thrive in a humid, shady spot, and will require regular misting and moderate watering. Through the summer months, water once a week to keep the soil moist; in the winter decrease watering to once every couple of weeks and allow the soil to dry out completely before watering again.

The rattlesnake plant should be potted in a free-draining, sandy soil. Ample drainage is necessary to allow the water to flow through freely, preventing any root rot. If the plant is exposed to air that is too cold or dry you may notice the leave start to go brown and droop.

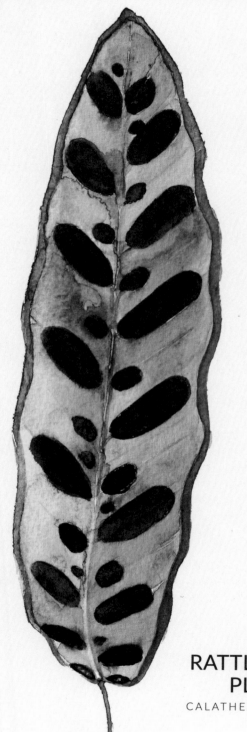

RATTLESNAKE
PLANT

CALATHEA LANCIFOLIA

Chlorophytum comosum 'Vittatum'
Spider Plant
South Africa

A fast-growing perennial, the brightly variegated spider plant is one of the most widely known house plants around, valued for its long, linear, arching leaves, its cascades of baby plantlets, and its occasional tiny white flowers.

The spider plant is usually grown in light, airy conditions; it will appreciate being in a sunny position as this will increase the vibrancy of the leaves. Too little sun and the spider plant tends to turn a little yellowy.

Watering should be determined by the growing patterns. When the plant is growing throughout the summer months you will need to water generously once a week; regular misting will also keep the leaves looking healthy. Be careful not to get drops of water on the leaves during any direct sunlight though, as this will mark and potentially scald them. During the winter months, decrease the level of watering, as the plant will go through a dormant period when overwatering can result in root rot.

These fruitful plants propagate themselves readily, producing long, arching stems at the end of each of which grows a small tuft of leaves – a miniature spider plant. These can be pegged into new soil until they take root.

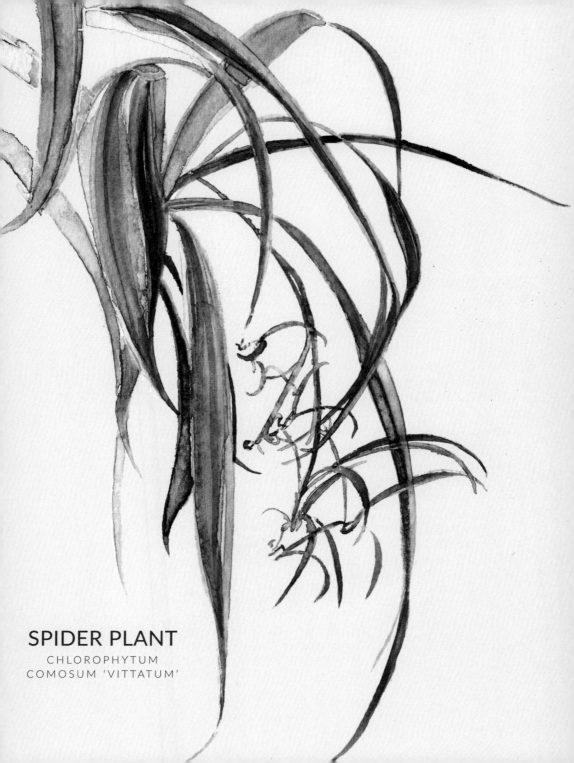

SPIDER PLANT
CHLOROPHYTUM
COMOSUM 'VITTATUM'

Epipremnum aureum
Devil's Ivy
Polynesia

The perfect indoor climbing and hanging plant, the devil's ivy is one of the easiest to grow of its genus, and can reach 2 m/6 ft or more in good conditions. It used to be known as *Scindapsus aureus*, and is still sometimes available under that name.

During the summer months, water liberally. This will promote strong growth of the trailing stems, allowing them to achieve long lengths without breaking. Water far more sparingly throughout winter. Always be sure to let the top of the compost dry out slightly between waterings, as you do not want it to be sodden the whole time. Mist the leaves frequently as this plant likes high humidity.

The devil's ivy requires moderate sunlight throughout the year, which will help to promote the bright yellow splashes of colour on the variegated leaves. It will appreciate a strong light source throughout the winter months and a few hours of direct sunlight in the summer.

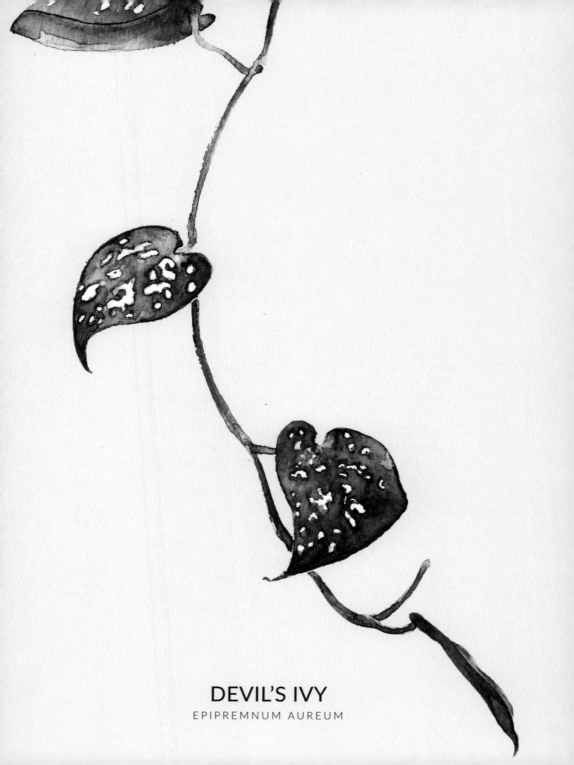

DEVIL'S IVY

EPIPREMNUM AUREUM

Ficus elastica
Rubber Plant
Northeast India and Malaysia

A species of plant in the fig genus, the rubber plant may be one of the most popular of the larger house plants to have in the home. The appeal is in the large, dark, thick, rubbery leaves that have a shine making them almost seem to be made out of plastic.

Thriving in wet, tropical conditions, rubber plants will tolerate drought but prefer a humid environment, with indirect sunlight. Position your plant where it will receive a nice amount of morning sun followed by periods of shade. Too much direct sunlight can damage the colouring of the leaves.

Be careful not to overwater rubber plants; watering once a week and allowing the soil to almost dry between watering should be sufficient. If the plant starts to lose leaves, this is often a sign of overwatering.

As your rubber plant grows and increases in height it may be necessary to support the central stem with a stout bamboo stake or moss pole in order to maintain the plant's strength and appearance.

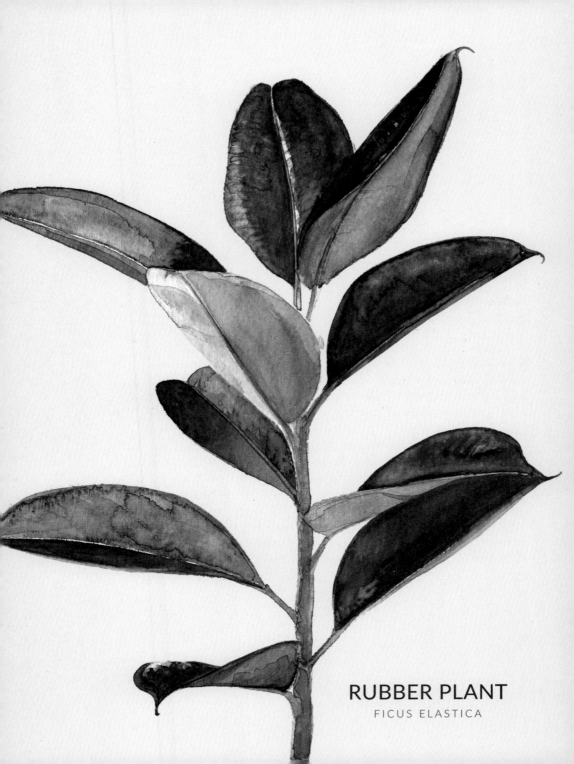

RUBBER PLANT

FICUS ELASTICA

Ficus lyrata
Fiddle Leaf Fig
West Africa

A popular ficus for the home, standing tall with its beautiful ornamental, violin-shaped leaves, the fiddle leaf fig can take up to fifteen years to reach full maturity. It enjoys good light and will be happy in a bright, south-facing room or conservatory. However, do not place it in direct sunlight as this can burn and discolour leaves.

Care should be taken when watering. Do not overwater but make sure that the soil doesn't dry out completely, as this can cause leaves to brown and fall off. Water once a week, allowing the top layer of soil to dry out between watering. It is better to underwater rather than overwater, as overwatering can sometimes be fatal.

When the plant is young and still growing you will need to repot every couple of years in order for the roots to utilise the space they need. However, as the ficus hits maturity you will only need to replace the top soil yearly.

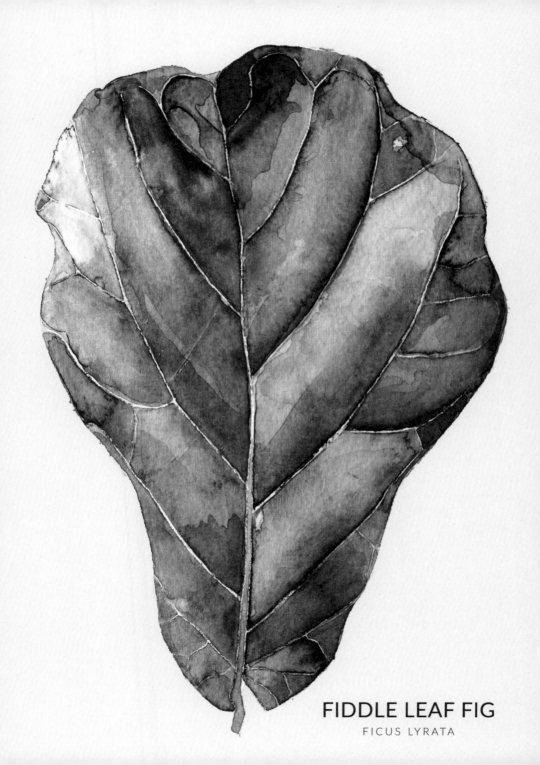

FIDDLE LEAF FIG

FICUS LYRATA

Fittonia
Nerve Plant
Peru

Favouring the humidity of the Peruvian jungle, fittonia is a creeping beauty that trails along the jungle floor. There are several species and hybrids available. One of the most popular is *Fittonia albivenis,* whose bright green leaves are attractively marked with silvery-white veins; other varieties have leaves with pink veins. Most forms have small leaves, and will occasionally produce small white or yellow flowers during the summer months.

Quite a tricky plant to grow inside due to the dry conditions, fittonia is at home amongst ferns in the bathroom where they can soak up steam. Alternatively they will thrive in a terrarium or bottle garden. They do best if given constant warmth and humidity; regular misting will be appreciated, and good light but not direct sunlight.

If the plant or the roots become too dry you will notice that the leaves and stem start to become limp; watering every few days in the warmer summer months can prevent this from happening. Be aware that fittonia are also prone to stem and root rot if they are over-watered.

Fittonias deteriorate with age, and younger plants are the most attractive. They are quite easy to propagate by tip cuttings which can provide you with new plants and also encourage production of side shoots and bushy growth from the parent plant. Place the cuttings in a moist, standard potting mixture and they should quickly root.

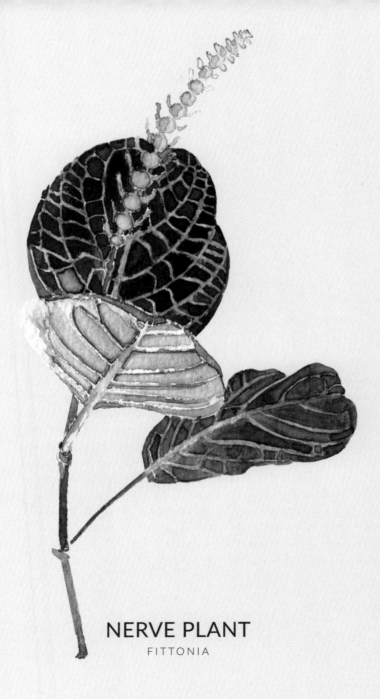

NERVE PLANT

FITTONIA

Howea forsteriana
Kentia Palm
Lord Howe Island, Australia

These slow-growing plants are very tolerant of shade, dry air and general neglect and are among the most popular house plants. The leaves or fronds of Kentia palm are some of the widest when compared to other popular palms, and each leaflet can grow up to 30 cm/1 ft long. Leaves can be damaged by strong, direct sun, so a position in bright but indirect light is ideal. Plants form one central stem but often several palms are planted together to give a more attractive effect. These plants need plenty of room, as they can easily top 2 m/6 ft tall; their rather upright habit of growth has led to their alternative common name of sentry palm. While the plants will tolerate dry air, the leaves can start to turn yellow under dry conditions; regular misting will keep them in the glowing health. Kentia palms rather resent root disturbance, so should be repotted only when it is absolutely necessary.

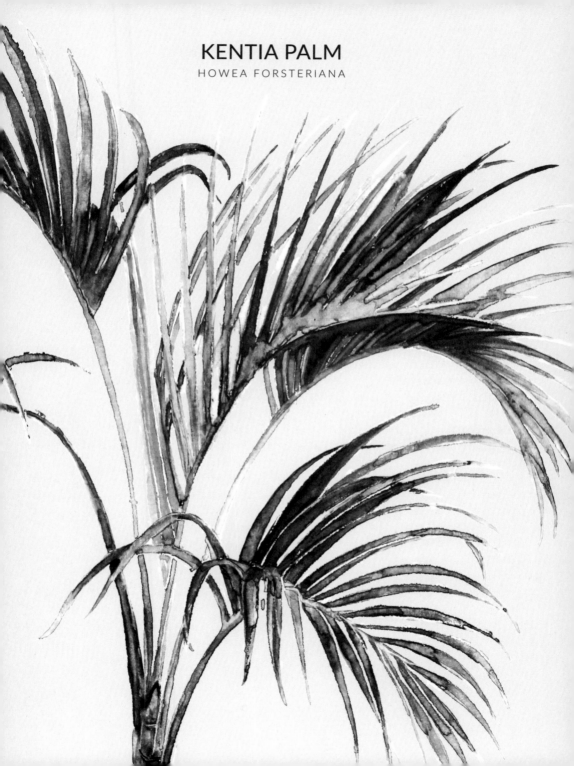

KENTIA PALM

HOWEA FORSTERIANA

Isolepis cernua
Club Rush
South America

As the name suggests, club rush is a flowing green, tufted, rush-like plant with long, grassy leaves and small clusters of brown spikelets. The foliage forms a graceful fountain shape and its appearance has given rise to its alternative common name of fibre optic plant. It is usually found in grassy meadows in places from as far apart as Siberia to South America, but it can also work really well as a domestic house plant. It is sometimes sold under the name *Scirpus cernuus*.

Club rush requires a moist and humid environment; keep watering constantly throughout the summer months, so the compost is always very moist or even wet. Misting is also advised to increase the moisture around the leaves. If the plant is kept in a very cool room, watering can be decreased slightly during the winter, but the compost must never be allowed to dry out. Club rush enjoys the sunshine, so make sure it is treated to the morning sun and then give a shady rest in the afternoon.

This plant is easy to propagate by division of the parent plant in early or mid spring.

CLUB RUSH

ISOLEPIS CERNUA

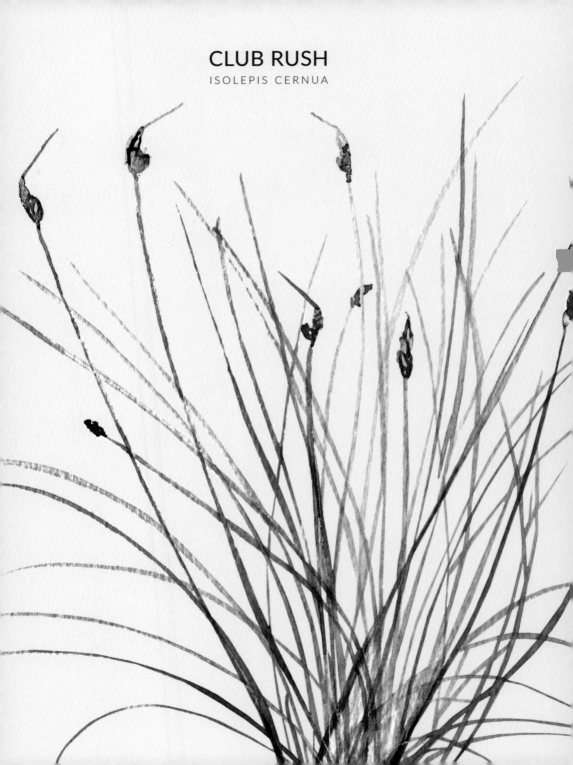

Monstera deliciosa
Swiss Cheese Plant
Southern Mexico

The unusual leaf structure of these aptly named plants is definitely part of their great appeal as house plants. The leaves are large, reaching lengths of 45 cm/18 in or more. They start off undivided in young plants, becoming cut and perforated as they develop (these type of leaves are known as fenestrate leaves). These giant plants – they can grow up to 6 m/20 ft – can become unruly and they require support in the home. A moss pole is a popular method of support; Swiss cheese plants produce aerial roots and these can be pushed into the moss, or guided back into the compost, to help hold the plant steady. Keep out of direct sun but in good, bright light, and mist the leaves occasionally if the air is dry.

Flowering is rare in the home but may occur on mature, well-grown plants. Flowers are like a white arum lily, with a central spadix or cone, which very slowly matures to an edible fruit. Monstera has many uses across the world; in Mexico they use the aerial roots for ropes and to weave baskets, and the leaf is pulped and drunk to relieve arthritis!

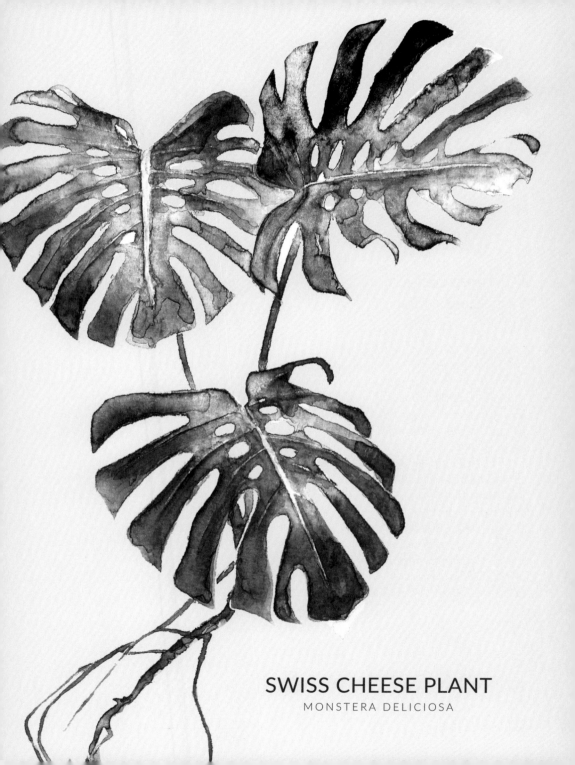

SWISS CHEESE PLANT

MONSTERA DELICIOSA

Monstera obliqua
Swiss Cheese Vine
Brazil

The lesser know of the two Monstera, the obliqua is remarkable in the fact that its bizarre leaf formations appear almost immediately after a new leaf surfaces. Natural oval holes adorn each leaf, making this a delicate plant to house and re-pot, tearing of the leaves can be pretty common, it will be happy sat in a large pot in the corner of the room as well as draping out of a sturdy hanging basket.

As long as bight and direct sunlight is avoided, the *Monstera obliqua* can survive in partial light and shade, if the plants do not get enough sunlight you may notice that the leaves start to yellow and shrivel, if this is the case move to a brighter position.

Water sparingly, although this huge plant looks as though it will need a lot of watering, year round weekly waters will be enough, and be sure to allow the top few cm's of compost to dry out before watering again.

The leaves will appreciate a frequent sponging to remove dust, and you will be able to train aerial roots into the potting mixture with time.

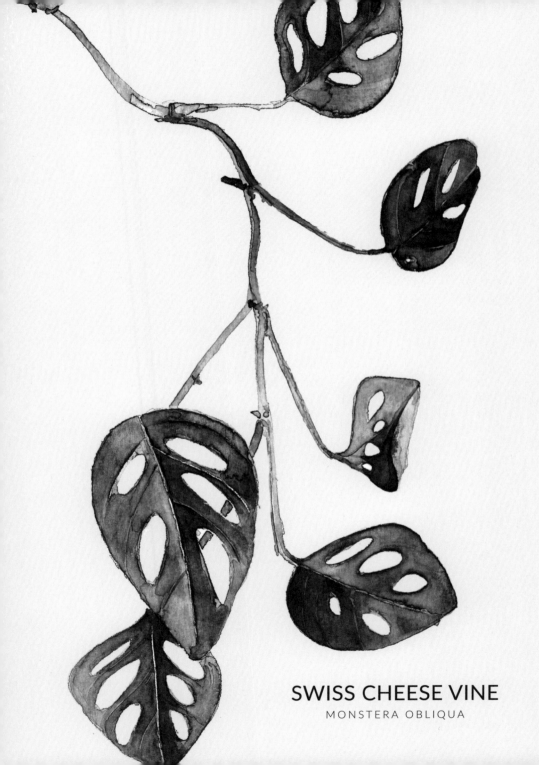

SWISS CHEESE VINE

MONSTERA OBLIQUA

Muehlenbeckia complexa
Maidenhair Vine
New Zealand

This foliage plant is a relatively new introduction to the house plant market, but in a hanging basket it will complement any room. The small, spherical, evergreen leaves trail down sprawling, wiry stems, and if you are lucky you will be greeted with small clusters of greenish-white flowers during the summer months.

Relatively easy to look after, the maidenhair vine will thrive in indirect sunlight or light shade. Water regularly from spring to autumn and then more sparingly during the winter months.

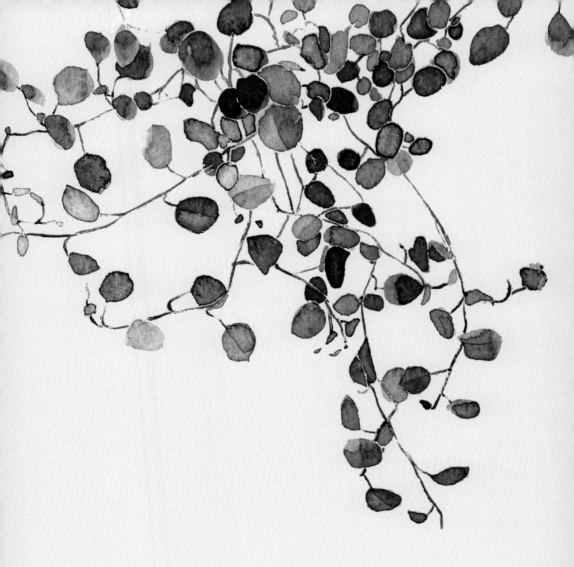

MAIDENHAIR VINE

MUEHLENBECKIA COMPLEXA

Musa acuminata 'Dwarf Cavendish'
Banana Plant
Asia

Grown indoors since the nineteenth century, when they were displayed extravagantly in large glasshouses, banana plants are still real statement house plants – as long as you have enough room! Even dwarf varieties such as 'Dwarf Cavendish' can make quite large plants indoors.

Be especially careful around the leaves of banana plants as although they are large, quick growing and look rather tough, they are almost as delicate as paper and tear very easily. A conservatory is the ideal spot for this tropical plant, which needs warm conditions and good light, with some direct sun. Mist frequently to keep the atmosphere humid to replicate the plant's natural environment. A banana plant will also require copious amounts of watering, so pick a large pot, but ensure it has plenty of good drainage. The compost should be kept moist at all times.

The large, tropical, decorative leaves make Musa a popular choice for a house plant, but don't expect to see any fruit production in the home environment.

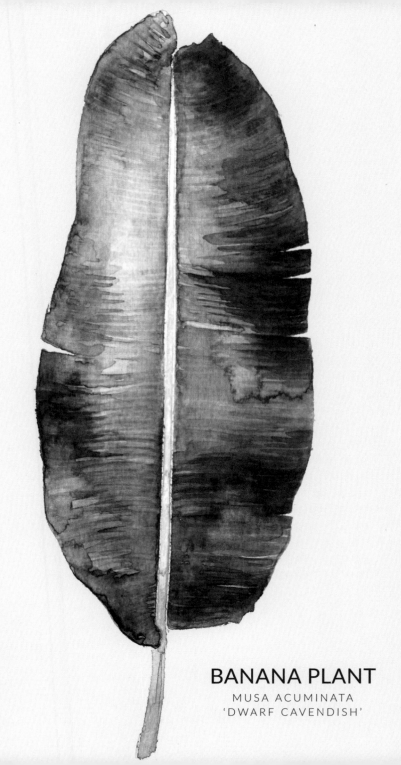

BANANA PLANT
MUSA ACUMINATA
'DWARF CAVENDISH'

Nephrolepis exaltata
Boston Fern
South America

The Boston fern can be found in tropical conditions, hiding below the canopies in the humid forests and swamps of South America, Mexico and the West Indies. The delicate arching leaves, known as 'fronds', are cut into hundreds of segments, giving the plant the feather-like appearance it is famed for.

Used to living under the protection of larger trees and plants, the Boston fern will survive long periods of shade, but it prefers bright, indirect light. Keep it out of direct sun, which will crisp the fronds. Never allow this plant to become dry at the roots; the potting soil should be kept damp at all times. As long as the room temperature stays relatively warm, water freely to ensure that the compost never dries out.

Your Boston fern will be very happy potted in a hanging basket. As long as there is plenty of natural light, a bathroom could be the ideal environment to allow this fern to get the constant humidity that it desires.

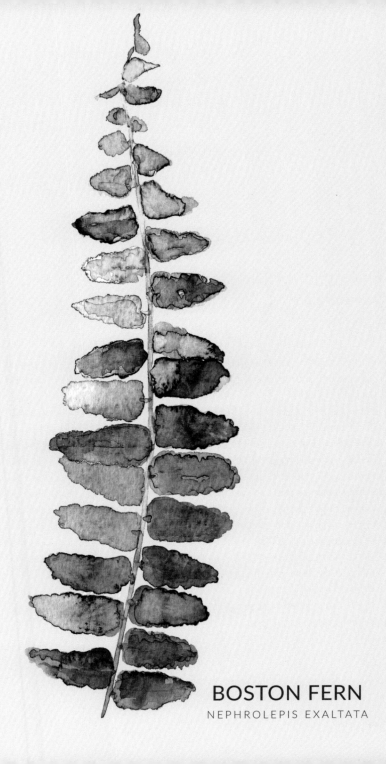

BOSTON FERN
NEPHROLEPIS EXALTATA

Philodendron xanadu
Winterbourn
South America

This is a large genus of mainly compact, but wide-leaf plants, the striking bright green, leathery leaves of the Winterbourn are often made up of up to 20 separate lobes.

The older a xanadu plant gets the better it seems to look, growing in width rather than in height sometimes reaching spans of up to 1.5 m/5 ft, you will rarely need to trim a xanadu as its clumping growth pattern will form an attractive shrub all by itself. Because of its widespread stems, it is important to place your xanadu in an area that it can easily grow to its full potential, without being constrained and squashed, which could lead to leaf damage.

Grow philodendrons in bright filtered sunlight, as direct sun can damage the leaf surface. Although they will put up with very low light, a *Philodendron xanadu* prefers more light than most other Philodendrons in order for it to keep its compact form, not enough light and you will notice the plant stems stretch to try and reach the sun.

Water regularly, but allow to dry out in between waterings as the xanadu can be prone to root rot, and it is also very tolerant to drought so choose a free-draining compost.

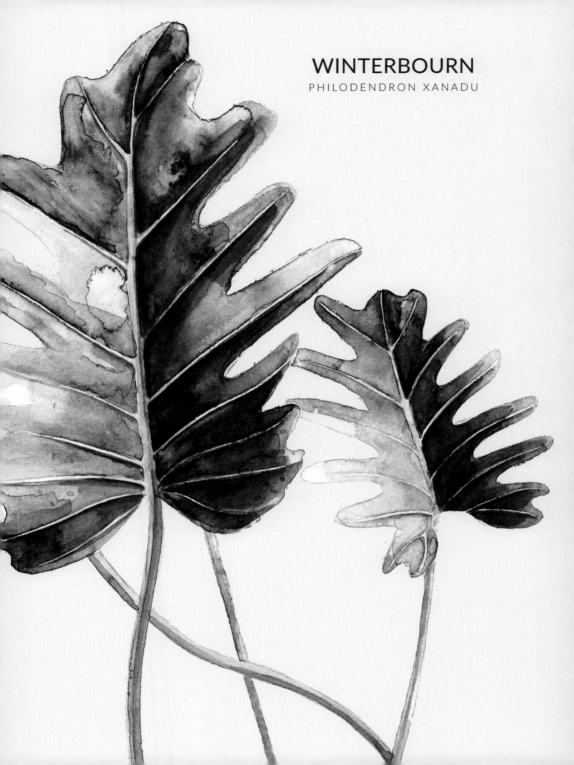

WINTERBOURN

PHILODENDRON XANADU

Pilea peperomioides
Chinese Money Plant
Yunnan Province, China

This beauty may be well on its way to overtake in popularity the standard money plant (crassula) that we have loved for years. Standing strong with is erect stem and round, dark green leaves, the Chinese money plant's unique silhouette will attract great attention when potted up in any home.

Pileas are relatively simple to grow indoors. Set them in a bright position but out of direct sun; water regularly during the summer months but sparingly through winter. They like humidity, so misting between waterings is advisable. You will soon notice that your adult pilea will start sprouting many children from its base, and these can easily be rooted to propagate the plant. If your plant is happy it may produce tiny green flowers that are sometimes tinged with pink.

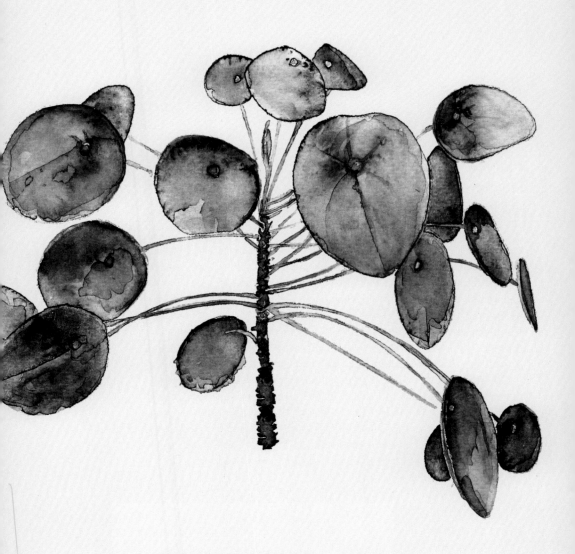

CHINESE MONEY PLANT
PILEA PEPEROMIOIDES

Platycerium bifurcatum
Staghorn Fern
Australia

The imposing staghorn fern bears large and elaborate fronds that are usually separated at the ends like stags' antlers – hence the name – or seaweed. These ferns are epiphytic, meaning in their natural habitat they grow clasping to a tree, so in your home they are great mounted in hanging baskets or on a trellis.

A staghorn fern will typically have two types of leaves. Sterile fronds at the base of the plant, which build up and go brown with time, cling on and support the plant, while spreading, spore-bearing fertile fronts arise above.

Growing under the canopy of trees in the wild means that staghorn ferns do not need much light, and they will be happy in a shady room with occasional direct light. They do need adequate moisture, and should be misted frequently with tepid water. Large specimens should start to produce pups, which will grow around the base of the plant. These can be cut off with a sharp knife, wrapped in some sphagnum moss and rooted to form a new plant.

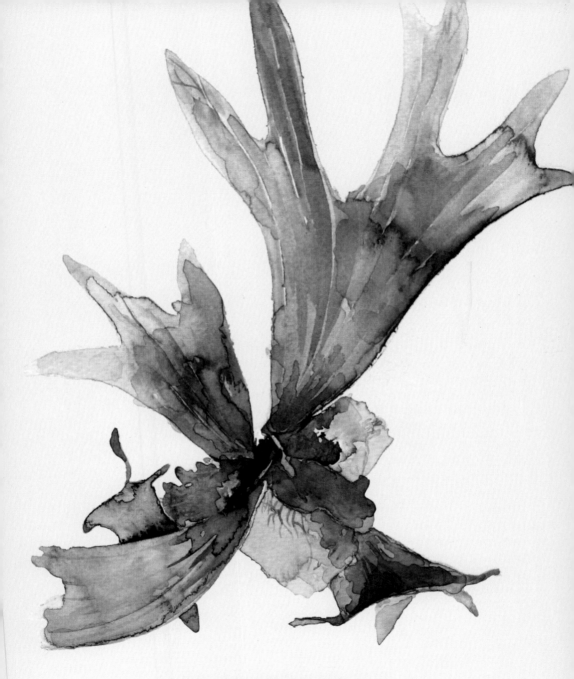

STAGHORN FERN

PLATYCERIUM BIFURCATUM

Sansevieria trifasciata
Mother-in-Law's Tongue
West Africa

With very attractive, tough, blade-like leaves, the mother-in-law's tongue forms a tall plant up to 1 m/3 ft high. The leaves are generally dark green with speckled bands of lighter green, or yellow markings along both edges.

Very tolerant of neglect, mother-in-law's tongue will grow happily in light or shade. The only thing that is highly detrimental is overwatering. Water the plant moderately in summer, leaving the top half of the soil to dry out in between waterings, but water very sparingly in winter, just enough to prevent the soil from drying out completely.

Your mother-in-law's tongue will need repotting infrequently as the plant is very slow growing, only one or two new leaves being produced each year. Flowering is unusual in the home but if you are lucky enough for your sansevieria to bloom you will see a tall spike of fluffy, greenish-white flowers from the base of the plant.

Mother-in-law's tongue is one of the best plants for filtering and creating clean air in your home.

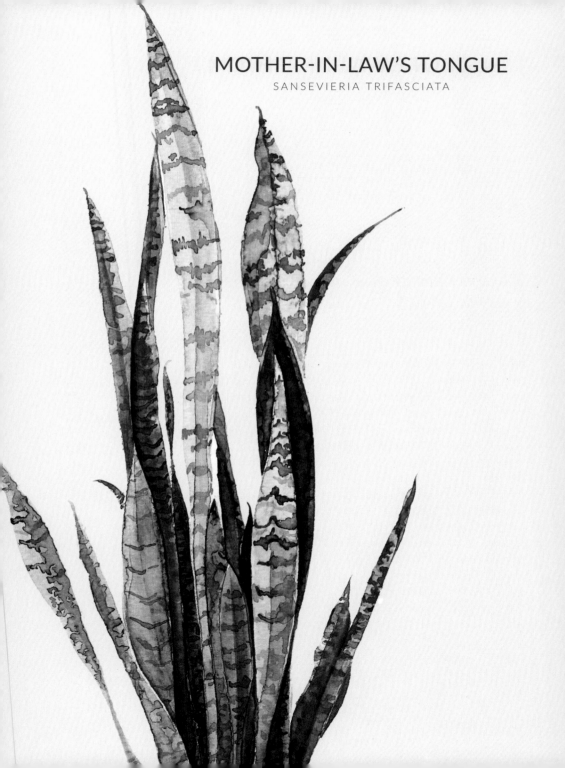

MOTHER-IN-LAW'S TONGUE

SANSEVIERIA TRIFASCIATA

Schefflera arboricola
Umbrella Plant
China

An evergreen shrub popular as a house plant, the umbrella plant is often obligingly tolerant of neglect. It gets its common name from the tall standing stems that support an umbrella-like canopy of fingered green leaves. Variegated varieties such as gold-splashed 'Gold Capella' are the most popular. Umbrella plants have also been very popular as bonsai.

This plant can adapt to most conditions although it does prefer plenty of light, which is necessary to maintain good colour on variegated leaves. However, it should be shaded from strong, direct summer sun. It originates from the tropics and will thrive with humidity; watering and misting regularly will encourage healthy growth. The soil should be kept moist but not completely wet; throughout the winter months you will need to reduce watering to only a few times a month and allow the surface of the soil to dry completely before watering again.

Umbrella plants will need a sturdy support as they grow taller. An interesting feature of this plant is its ability to produce aerial roots in humid conditions, making a moss pole, into which you can train these roots, the perfect support.

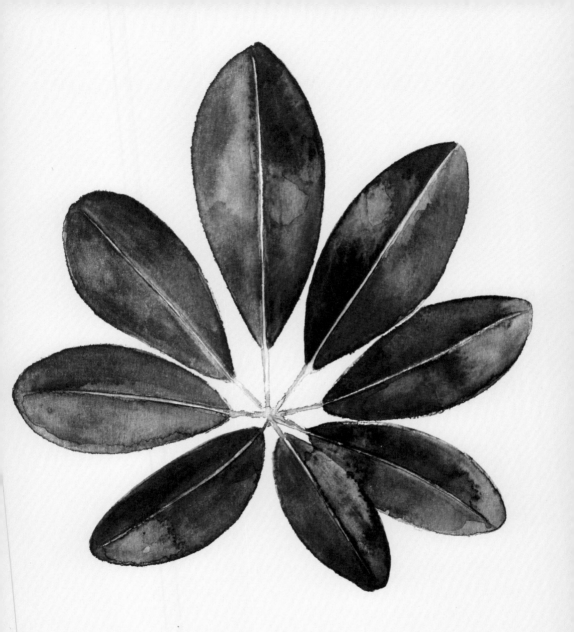

UMBRELLA PLANT
SCHEFFLERA ARBORICOLA

Yucca elephantipes
Spineless Yucca
Caribbean

This is a great foliage house plant known for its tough, sword-like leaves, and will stand tall in the corner of a room. Take care to choose the spineless yucca as a house plant, as some other species have dangerously sharp, spiky leaves – not recommended in a confined space indoors.

Your yucca will appreciate as much light as possible, and is happy in direct sun. It will also enjoy a spell in a sheltered spot outside during the warm summer months. Give it a deep pot with plenty of drainage, and use a free-draining compost. Water fairly generously during summer and then take a step back during the winter months, when you may need to water only once every few weeks. Many yucca species are grown as ornamental plants in gardens where they produce showy spikes of creamy-white, bell-shaped flowers. However, it is much less likely that yuccas grown as house plants will flower.

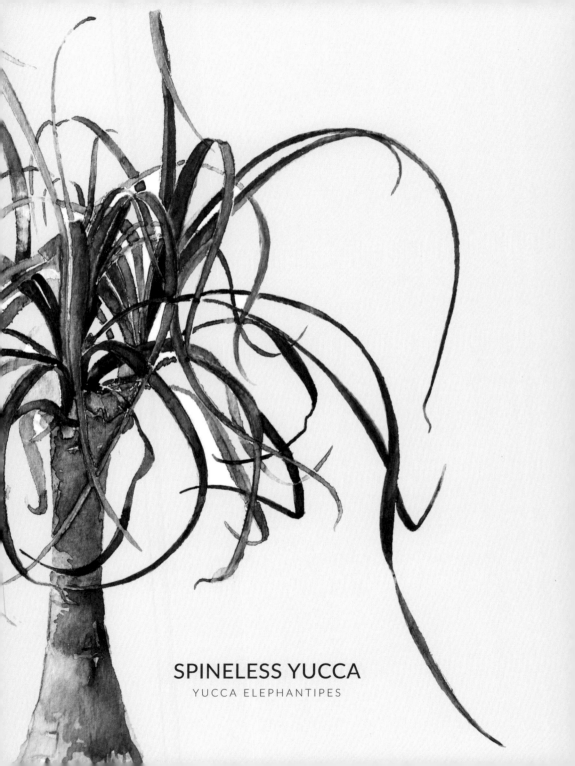

SPINELESS YUCCA
YUCCA ELEPHANTIPES

Zamioculcas zamiifolia
Zanzibar Gem
East Africa

A tropical perennial plant, Zanzibar gem has become a popular house plant since the mid 1990s, due to its ease of care and attractively shiny leaves. It can cope very well with neglect; although mostly an evergreen, it becomes deciduous during periods of drought, losing its leaves and using water stored in its large underground rhizome. With this in mind you can tell it is also very easy to overwater the Zanzibar gem, so make sure that the soil is completely dry between watering to prevent any root rot.

Zamioculcas can also cope very well with long periods of low light conditions; however, your plant will be at its best if it is exposed to high amounts of indirect sunlight and a warm, humid environment.

These plants produce rather insignificant arum-like flowers in their natural habitat but rarely flower in the home. One thing to be aware of is that the sap that comes from leaves can be potentially toxic and cause minor skin irritations.

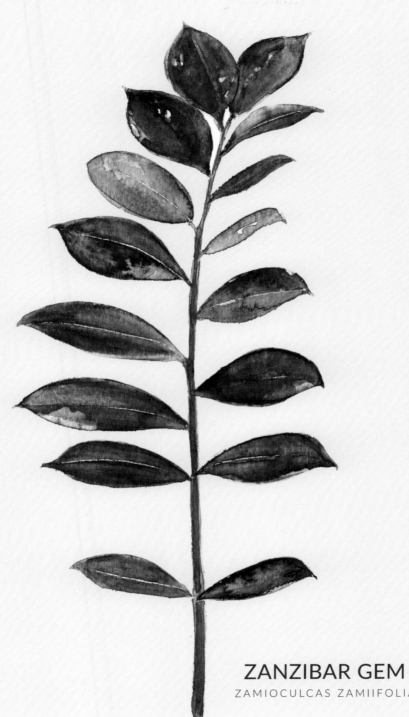

ZANZIBAR GEM

ZAMIOCULCAS ZAMIIFOLIA

INDEX

NOTES

NOTES

NOTES

NOTES

Inspiring | Educating | Creating | Entertaining

First published in 2017 by Aurum Press
an imprint of the Quarto Group
The Old Brewery, 6 Blundell Street
London N7 9BH, United Kingdom
www.quartoknows.com

This edition first published in 2021 by White Lion Publishing

Illustrations © 2017 Maaike Koster
Text © 2017 Emma Sibley

A catalogue record for this book is available from the British Library.

ISBN 978 0 7112 6867 8

10 9 8 7 6 5 4 3 2 1
2025 2024 2023 2022 2021

Typeset in Lato by Tim Peters (www.timpeters.co.uk)
Cover design by Rita Peres Pereira

Printed in China